T0160184

LITTLE BOOK OF

Gucci

Published in 2020 by Welbeck
An imprint of Welbeck Non-Fiction Limited, part of
Welbeck Publishing Group
Based in London and Sydney.
www.welbeckpublishing.com

Text © Karen Homer 2020
Design © Welbeck Non-Fiction Limited 2020

A CIP catalogue for this book is available from the British Library.

ISBN 978-1-78739-458-2

Printed in China

20 19 18 17

LITTLE BOOK OF

Gucci

The story of the iconic fashion house

KAREN HOMER

WELBECK

Contents

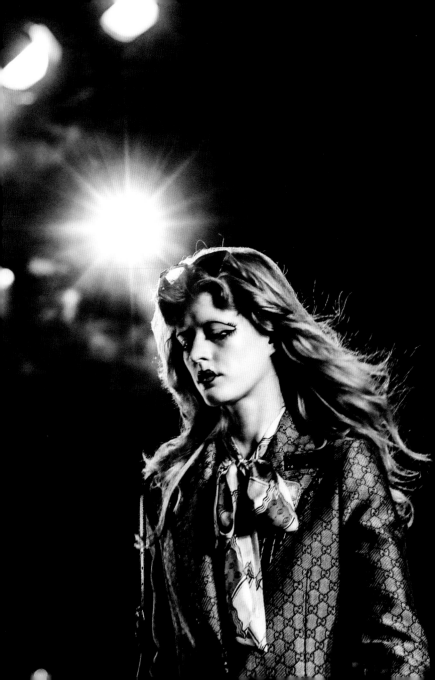

INTRODUCTION

Gucci

A versatile slang term based on the luxury fashion brand meaning okay/good/great/awesome/fresh/etc. Originally used in the streets but now popularized by the masses ... To be "all Gucci" is a wonderful thing indeed.

– Urban Dictionary

In 2021 Gucci will celebrate the 100th anniversary of Guccio Gucci opening his long-dreamed-of eponymous luxury leather goods store in Florence. In the past century the company has overcome many challenges, yet has managed to reinvent itself on several occasions and not only survive but thrive.

During the Second World War the problems were of a practical nature, with shortages of leather forcing other companies to close. Gucci, however, looked elsewhere and his resourceful solution - printing hemp fabric with the house pattern – not only enabled the business to continue producing luggage but also created an iconic design. After Guccio's death in 1953, the company passed into the hands of his sons Aldo, Rodolfo and Vasco and initially blossomed, with new designs, celebrity endorsements, high sales and global expansion. By the 1970s and 1980s, however, as Gucci's grandsons took a greater hand in the firm, more complicated issues arose, with family in-fighting leading to acrimonious legal challenges and a company on the verge of bankruptcy.

OPPOSITE In the Gucci Resort 2019 show, Alessandro Michele showed his veneration for the signature Gucci Diamante pattern but gave it his own twist.

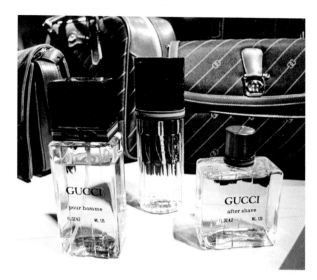

RIGHT In the 1960s, Gucci expanded their offerings to included fragrance lines for both men and women, a relatively inexpensive way to buy into the status of the brand.

The 1990s were make or break for Gucci, now owned by investment bank Investcorp, and the failing label employed a young, unknown designer, Tom Ford, in part because no one else would take the job. Alongside new CEO Domenico De Sole, Ford turned the company's fortunes around, reinventing the somewhat staid, traditional label with a massive injection of sex appeal and glamour, to make the double-G logo one of the most coveted status symbols of that hedonistic decade. Ford stayed until 2004, when, among rumours of a falling-out with Gucci's parent company, he left to start his own label.

The creative directorship of Gucci during the following decade was held by Italian designer Frida Giannini. Although her stewardship of the label has been criticized by some as too traditional and unimaginative, her cool, calm and collected demeanour, along with a native understanding of Gucci's customer base, allowed the brand to hold steady in a difficult economic climate. And to give credit where it's due, Giannini

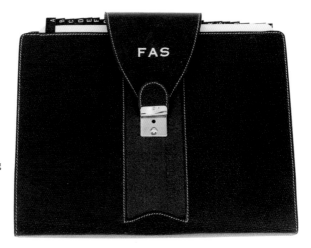

designed a number of signature pieces that would become modern classics.

By 2014, the brand was slipping once again. This was in part due to the changing landscape of fashion since the millennium. As well as the influence of the Internet and social media, which radically altered the way fashion reached consumers, a kind of reverse snobbery had seen designer labels fall out of favour as aspirational status symbols. Luxury brands were forced to reinvent themselves, and, for Gucci, that transformation came at the hands of another relative unknown: Alessandro Michele.

Michele, with his "eclectic and flamboyant aesthetic" (*The Telegraph*) has been designer-in-chief at Gucci since 2015 and is probably the most exciting fashion designer of our times. His eccentric genius is lauded not only by fashion pundits but also by millennial style commentators and, of course, shoppers themselves. His talent at combining historical influences with streetwear, the gender fluidity of his garments and show casting,

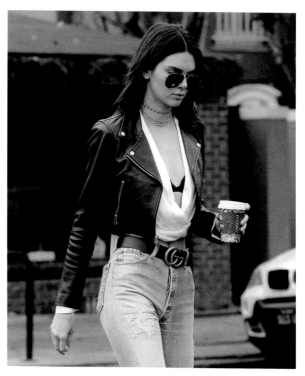

and the sheer technical skill of the design team, have allowed the
label to reach the very pinnacle of fashion, fame and fortune.

Guccio Gucci's original dream was to make fine leather
luggage for the social elite. A century later, the Gucci signature
print or double-G logo is as likely to be seen on the bum bag or
fanny pack of a hip-hop star or the belt of an off-duty model –
the new social elite – as on the traditional handbag of a Euro
royal. Unimaginable as it might have seemed to Gucci and
his sons, their label is no longer just for aristocrats and social
climbers – it is now for the Instagram generation.

RIGHT Rapper Gucci
Mane arrives at the
Spring/Summer 2020
show in Milan.

The Early Years

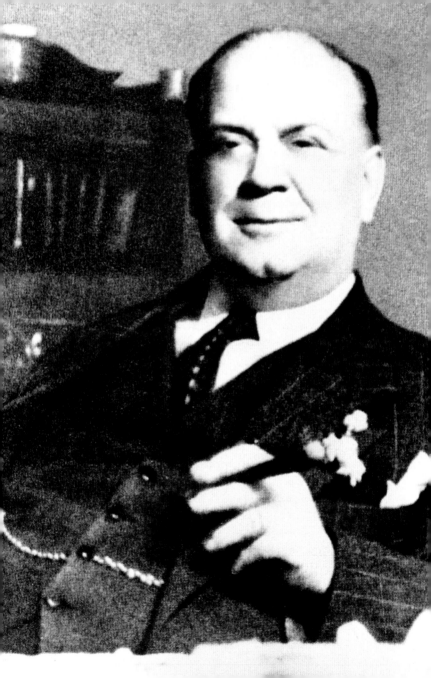

BEGINNINGS
OF AN ICONIC BRAND

Guccio Gucci was born on 28 March, 1881, in the Tuscan
city of Florence. His father was a modestly successful
leather craftsman and milliner who came from a long line
of leather-makers.

However – ironically, given his future success – the young
Gucci rejected the family trade, preferring instead to
leave Italy to travel and work in Europe. In his late teens
he arrived first in Paris, then settled for several years in London,
where he worked at The Savoy hotel, starting as a busboy and
rising to the respected position of maître d'.

During his time working at The Savoy, Gucci dealt with the
many glamorous celebrities and royals of the day who stayed in
the hotel, and he observed in particular that they always travelled
with volumes of beautifully crafted, refined luggage. He also
became fascinated by London's many traditional craftsmen and
leather-makers, especially the company H.J. Cave & Sons, which
supplied the highest quality goods to those wealthy enough to
afford them. Lastly, Gucci noticed that many of these aristocrats
had an obsession with polo playing and horse racing, something
that would influence his designs from the very beginning.

OPPOSITE Guccio Gucci, the patriarch of the Gucci family business.
It was his dream from when he was a teenage porter at London's
Savoy hotel to found his own luxury leather goods label.

RIGHT The glamorous Savoy hotel in London played host to some of the biggest names and celebrities of the day. Working as a busboy, Guccio Gucci was inspired by the style and refinement of its guests.

On his return to Italy, just after the turn of the twentieth century, Gucci joined the Milan leather manufacturer Franzi (Gucci's father's business having gone bankrupt), and there he learned the trade that would eventually make him a household name. Over the next decade he worked diligently for Franzi, while dreaming of his own business. He slowly began to design and produce leather goods, culminating in a move back to Florence in 1920 and the opening of his first eponymous store on Via della Vigna Nuova in 1921.

Harking back to his years observing the wealthy guests at London's Savoy hotel, and wanting to target this social class with his luxury goods, Gucci's earliest leather creations were saddles and saddlebags. Despite the fact that demand for these goods was beginning to fall at the beginning of the twentieth century, thanks to the rise in automobiles, Gucci never lost his taste for equestrian style, and riding-inspired embellishments

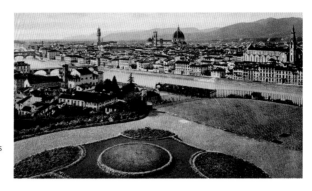

RIGHT From circa 1900, this photochromic image shows Guccio Gucci's beloved hometown of Florence. Gucci finally opened his eponymous store on Via della Vigna Nuova in 1921.

became a big part of the brand's heritage, and they continue to be used by the label to this day.

Having so admired the traditional leather-makers in London, from the very beginning of his business Gucci emphasized using the most accomplished Tuscan artisans and, alongside his store, founded a workshop so that he had complete control over the quality of the leather goods he supplied. In fact, Gucci was so devoted to the British tradition of craftsmanship that advertisements from the time promote the store as stocking "English leather goods". Gucci was also unusually aware of the changing status of women, who were becoming increasingly emancipated during the 1920s. In a 1924 letter Gucci wrote about his new range of "ladies' bags", which would become a huge part of Gucci's product line in later years.

As the demand for equestrian goods waned, he began supplying pieces of luggage, and within a decade handbags, gloves, shoes and belts had been added to his repertoire. During the 1920s and early 1930s, Gucci's reputation grew ever stronger and the wealthy flocked to Florence not only for saddlery but for the label's other high-quality leather products.

In 1901 Gucci married Aida Calvelli, a seamstress, and the couple raised six children: a daughter, Grimalda; and four sons,

Enzo (who tragically died aged nine), Aldo, Vasco, Rodolfo (who gained fame as a movie actor under the stage name Maurizio D'Ancora before joining the family firm) and Ugo, Aida's son whom Guccio adopted. Gucci's sons Aldo, Rodolfo, Vasco and Ugo would all become involved in the company, both on the design and business sides.

Aldo, the first of the sons to join the company, in 1933, would become one of the greatest influences on the success of the family firm. He was an extremely talented designer and also a savvy businessman, and under his guidance during the 1930s the Gucci brand and its logos became firmly established. Aldo immediately saw the need for an official emblem to make

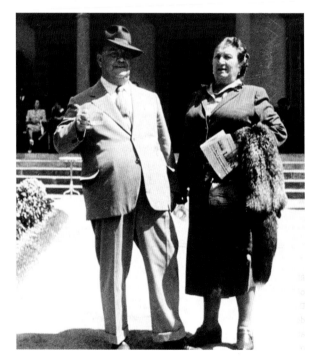

RIGHT Guccio Gucci and his wife in Italy in the late 1940s, enjoying the success of his business. Aida carries a fine leather bag that epitomizes Gucci quality.

Gucci's products stand out, and in a stroke of genius he took the double Gs from his father's name and designed the interlocking pattern that is so instantly recognizable today. As a brand logo it is an immensely clever, simple, yet aesthetic design. The fact that it is not immediately obvious that it is made up of two letter Gs (so is usually shown beneath the name Gucci itself) has helped create an aspirational logo that is still in use almost 90 years later. Over the years it has been used diversely across the Gucci range: printed onto every conceivable fabric for clothes, embossed onto leather accessories, forged into metal clasps for bags and belts, made into hosiery and been transformed into interlinking bracelets, watch straps and rings.

RIGHT An example of the interlocking GG Diamante that Aldo designed in the 1930s at that is still universally recognized to this day.

RIGHT Maurizio, son of Rodolfo, took over as the head of the fashion house in the 1980s, selling the company and his grandfather's legacy in 1993.

As the beginning of the Second World War approached, Italy fell under Mussolini's fascism, and, as a result of the country's alliance with Nazi Germany, the League of Nations imposed sanctions that severely limited the import of leather. Forced to find an alternative, Guccio experimented with jute and linen, eventually settling on a specially woven, plain hemp fabric from Naples. Onto this he printed the company's first signature pattern: a series of small, interconnecting diamonds in dark brown on a tan background, an early version of what became known as the "Diamante" print. The patterned fabric, created to distinguish the Gucci brand from competitors, was made into some of the first Gucci suitcases and trunks, and proved hugely successful.

The material shortages during and after the war led Guccio to create another unlikely component that became part of a signature piece in the brand's history, and that is still produced today: the burnished semi-circular cane handle for his Bamboo bag, the body of which was originally shaped like a horse's saddle. The creation of these two substitutes – the bamboo handle and the printed hemp cloth – illustrated the Gucci family's resourcefulness and determination to succeed, and, where other companies closed down, the Gucci brand continued to grow. While the company resumed the use of leather when it was once more freely available, adopting pigskin as its house material, the immediately recognizable printed fabric remained. Guccio's wartime inventions proved to be some of the label's most iconic products.

Before the war, Gucci had opened one other store, on Rome's Via Condotti in 1938. This was followed in 1951 by a flagship opening on the elite Via Monte Napoleone in Milan, part of the fashion district and reputed to be Europe's most expensive street. Two years later, in 1953, Aldo oversaw the opening of the brand's first store in the United States, in New York's Savoy-Plaza Hotel – recalling Guccio's dreams from his time working at London's legendary Savoy hotel – but just two weeks later, Guccio died in Milan, aged 72. The family was in turmoil, especially when ugly facts surfaced about who was to take over the company: Gucci's daughter Grimalda – who had long been employed in the family firm – had not been left any share in the company. The same was true of Guccio's adopted son Ugo; he had already lost his stake through a troubled relationship with Guccio, who protested Ugo's membership of the National Fascist Party. In the end it was left to the three brothers, Aldo, Rodolfo and Vasco to honour their father's legacy and to continue to take the House of Gucci from strength to strength, into the future.

Signature
Pieces

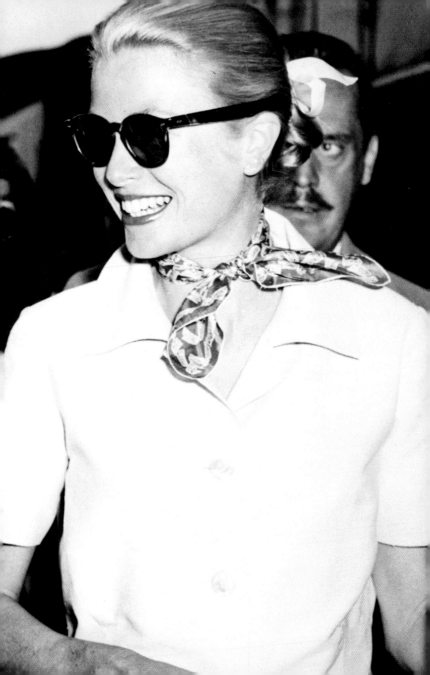

PRICELESS
LUXURY

"Quality is remembered long after the price is forgotten."

– *Aldo Gucci*

The death of Guccio Gucci in 1953, just two weeks after his first New York store opened, saw the firm pass into the control of his sons Aldo and Rodolfo (with Vasco and Ugo playing smaller parts in the business). The brothers were determined to keep their father's dream of an elite brand alive, and continued to focus on creating only the most memorable fine leather goods and accessories, which increasingly became coveted by the rich and famous. Aldo, in particular, had already proved his flair for both design and business, creating the iconic interlocking GG logo in the 1930s and helping to create the signature Diamante-printed fabric for luggage, which was a precursor to the Gucci trunks and bags so recognizable today.

In 1953 Aldo created possibly the most iconic of all of Gucci's products: the Horsebit loafer. Although his father had produced fine leather shoes with metal snaffles as early as 1932, Aldo redesigned the loafer and, in homage to his father's love of equestrian embellishments, added a gilded metal snaffle in

OPPOSITE Grace Kelly wearing the Flora silk scarf commissioned for her by Rodolfo Gucci and designed by Italian illustrator Vittorio Accornero in 1966. The print went on to be one of Gucci's most iconic patterns.

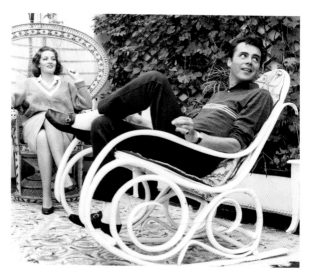

RIGHT An image of Dirk Bogarde wearing Gucci's Horsebit loafer in 1960. Designed by Aldo in 1953 in homage to his father's love of all things equestrian, it has a gilded metal snaffle in the shape of a horse's bit.

the shape of the mouthpiece on a horse's bridle. An immediate success, the simple yet elegant Gucci loafer has become one of the fashion world's most coveted status symbols – so important in fashion history that since 1985 it has been on permanent display at New York's Metropolitan Museum of Art.

The Horsebit motif itself subsequently became a detail that was added to many different accessories in many different ways. As a metal fastening it formed clasps for bags and belts, and much later was adorned with sequins by Frida Giannini, who created jewellery and chain-link straps out of the pattern. During the 1960s the Horsebit began to be printed onto fabric including silk and wool ties, scarves and clothing, and in the 1970s use of the print intensified further, with it appearing even on homewares that Gucci had started to offer. With Tom Ford's dramatic revival of the Gucci label in the 1990s, the Horsebit was given an ultra-stylized edge, appearing on high-heeled, patent red loafers and as oversized fastenings on belts and bags.

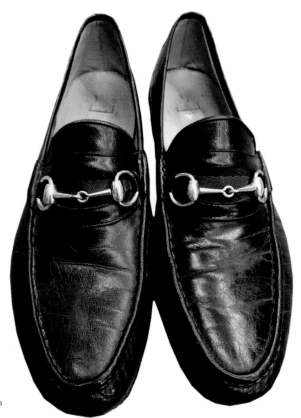

RIGHT The Gucci loafer has become so much a part of fashion history that it has been on permanent display at New York's Metropolitan Museum since 1985.

RIGHT The Horsebit motif was worked into many different forms including elegant gold chainlink jewellery.

Another equestrian-inspired creation that has become synonymous with the Gucci brand is the striped green–red–green grosgrain web fabric, inspired by the girth that circles a horse's body to hold the saddle on its back. The colours are said to have been chosen for their resemblance to traditional British fox-hunting jackets, and the stripe brings to mind military medal ribbons or public school scarves, both carrying connotations of aristocratic status. Over the years this signature woven fabric has been made into every conceivable product including belts, bag straps, scarves, watch straps and thongs for flip-flops, and has adorned everything from clothing to trainers. While Gucci has experimented with various different colours, most often with blue replacing the central red of the striped band, it is this red–green combination that remains most iconic, an instant identifier of the Gucci brand.

In the same year as Aldo designed the Horsebit loafer, he also reworked the Diamante fabric print, incorporating the double-G logo into the centre of the interconnecting diamonds, but keeping the same colours of dark brown on a tan background. This GG print, as it has become known, is crafted out of hard-wearing cotton canvas fabric, finished with a leather trim and often combined, in handbags and other small accessories, with the woven green–red–green web stripe. Again, the signature print has appeared on many different accessories, including wallets, shoes and hats, as well as being printed onto finer fabric to make clothing. In 1955 Aldo finally trademarked the interlocking Gs logo, it having become a sought-after status symbol, and it was subsequently routinely added to all Gucci products.

Accessories were very much the core of the Gucci brand during the 1950s and 1960s, and one handbag in particular became another signature piece that is still produced today: the Bamboo bag. Originally designed by Guccio, the saddle-shaped

OPPOSITE Charlotte Casiraghi models the Gucci signature Horsebit loafer, its metal snaffle based on a horse's mouthpiece, in 2017. The quintessentially stylish royal equestrian and granddaughter to Grace Kelly could not be a more fitting ambassador for the heritage range.

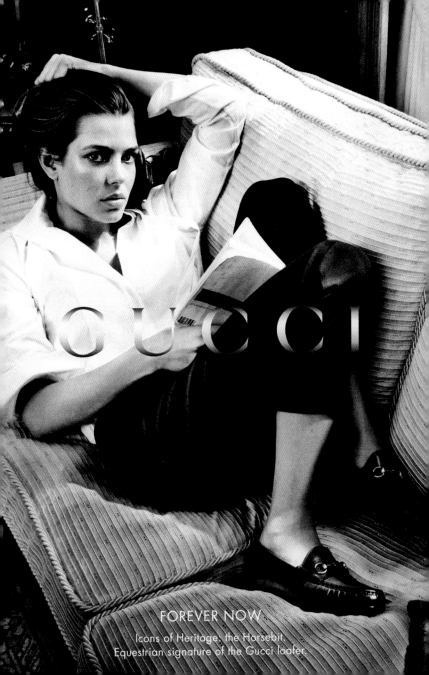

FOREVER NOW

Icons of Heritage: the Horsebit.
Equestrian signature of the Gucci loafer.

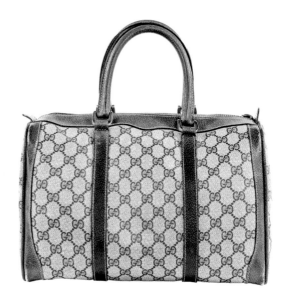

RIGHT Gucci's signature pattern, the double-G printed canvas fabric, was designed in 1953 by Aldo Gucci, a reworking of the original hemp Diamante print created by Guccio Gucci during the Second World War when the embargo on importing leather into Italy forced him to find new materials to work with.

bag is carried by a burnished bamboo-cane handle created out of necessity during the wartime leather embargo. Its covetable status increased as Hollywood legends including Ingrid Bergman and Elizabeth Taylor were spotted carrying it, and in later years it was a firm favourite of Princess Diana.

Renaming an accessory after a celebrity has created some of the most iconic bags of the twentieth century, and one of these is the Gucci "Jackie", dedicated to Jackie Kennedy, who in 1961, at the height of her popularity as the most stylish woman in the world, was photographed carrying an unstructured, unisex Gucci tote. It sparked a frenzy of copycat purchases and the Jackie became an integral part of the brand's collections during the 1960s. It was subsequently resurrected from the archives in the 1990s under Ford, and again in 2009 under Giannini, who renamed it "New Jackie", thus sealing its reputation as one of the most famous it-bags of all time. Another First Lady who was associated with

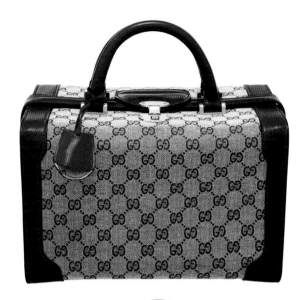

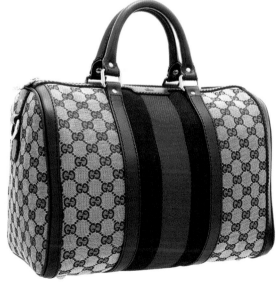

RIGHT The signature double-G printed fabric has been reworked in many different colours including classic red as shown in this small train case and black with a striking black-red web stripe in this version of the original GG Boston bag.

impeccable taste and style – and who also was devoted to Gucci – was Nancy Reagan. Legend has it that comedian Bob Hope, a family friend of the Reagans, teased Nancy that her personal nurse would tickle her under the chin with the words "Gucci, Gucci, goo!"

The patronage of celebrities was heavily encouraged by the Gucci family, who realized what the connection between their brand and glamorous socialites and actresses was worth. When, in 1966, Grace Kelly visited the atelier to buy a bamboo-handled bag, Rodolfo Gucci wanted to give the stylish princess a gift, but after deeming nothing in the label's collection suitable, he commissioned Italian illustrator Vittorio Accornero to design a painterly floral scarf in her honour. The print Accornero created – which featured 43 types of flowers, plants and insects in a vibrant kaleidoscope of 37 colours – was labelled the "Flora" and became a signature of the Gucci brand. Forever associated with the glamorous Hollywood-actress-turned-Princess-of-Monaco, it was an immediate success and inspired decades of floral designs among Gucci's silk accessories, including a relaunch of the pattern on canvas bags by designer Giannini in 2005.

The Gucci brand's long association with celebrities in film and music also helped the brand establish itself as the maker of iconic pieces. In the late 1940s and early 1950s, Gucci's bags appeared in Ingrid Bergman films – she carries a wooden-handled bag in Roberto Rossellini's *Stromboli*, a structured leather bag in *Europa '51* and a Bamboo bag in *Viaggio in Italia*. A friendship between the fashion label and filmmaker Michelangelo Antonioni led to Gucci bags appearing in films throughout the 1950s and early 1960s. Other actors were also drawn to the glamour of Gucci's products, and the company's historical archives feature images of many recognizable faces, including Audrey Hepburn, Peter Sellers, Sophia Loren and Elizabeth Taylor, visiting Gucci stores.

OPPOSITE Jackie Kennedy Onassis made the slouchy Gucci hobo bag an instant classic when she was photographed in 1961, reputedly using the handbag to shield herself from the paparazzi. She was subsequently regularly spotted carrying a version of the label's signature accessory which was renamed the "Jackie" in her honour.

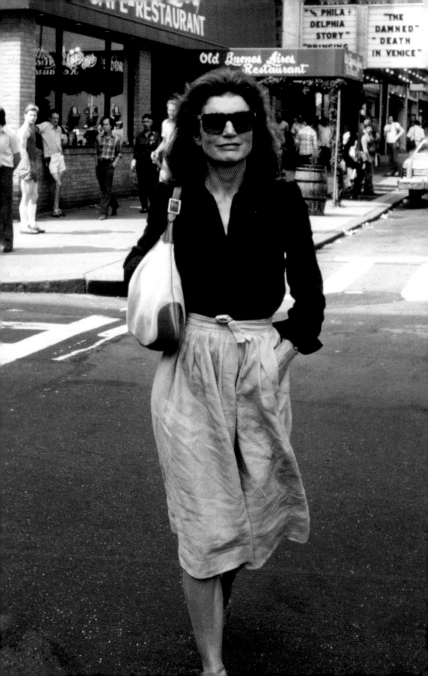

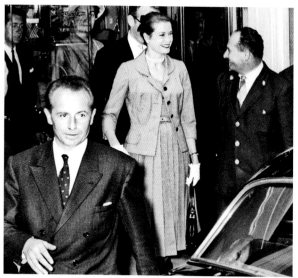

LEFT Grace Kelly leaving Gucci's flagship Rome store in 1959. The endorsement of royalty and celebrities like the Princess of Monaco greatly increased the reputation of the fashion label.

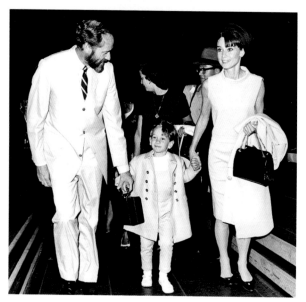

LEFT Audrey Hepburn with her husband, Mel Ferrer, and son in 1964. The actress and style icon carries a patent Gucci handbag with chain strap.

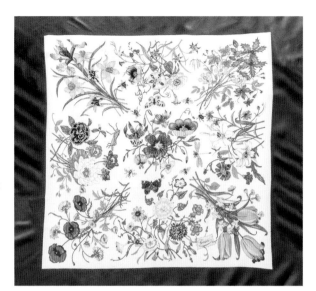

RIGHT A detailed shot of the Gucci signature Flora pattern, which features 43 types of flowers, plants and insects in a vibrant kaleidoscope using 37 colours.

In later years, too, the brand's instantly recognizable monogrammed fabric, striped belts and Horsebit loafers appeared in numerous Bond films, instantly imparting a sophisticated Euro-glamour, perfectly suited to the filmic world of international espionage. Similarly, later films including *Pretty Woman* and *Wall Street* have cameo appearances by Gucci storefronts and glamorous products, showing quite how strongly associated the brand is with wealth, status and conspicuous consumption.

By the end of the 1960s, Gucci's success in establishing its monogrammed Diamante fabric, interlocking Gs motif and red-and-green stripe contributed to the brand's global recognition as an aspirational fashion label, competing with the likes of Chanel and Louis Vuitton. But, despite the reputation of the brand, there were challenges ahead, as Gucci sought to expand over the next few decades.

LEFT By the 1950s Gucci had become one of the most high-end accessories brands. In this *Vogue* shot from 1956 the model carries a classic bamboo-handled structured black leather handbag with gold fastening.

OPPOSITE Gucci had a long association with film, with their bags frequently being used on screen, and many actors were fans of the label. Here Peter Sellers walks out of the Gucci boutique in Rome in 1966.

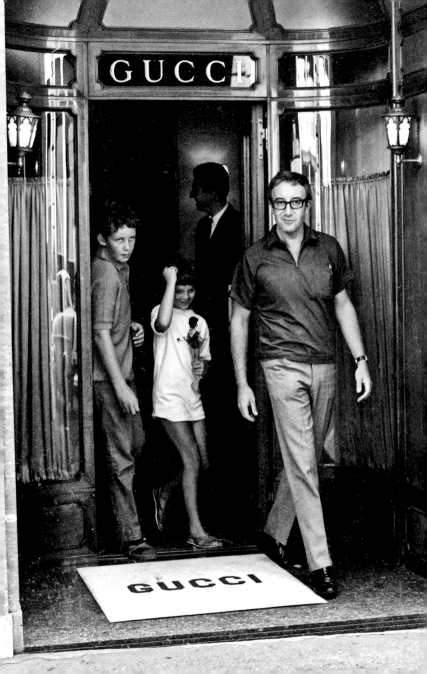

Going Global

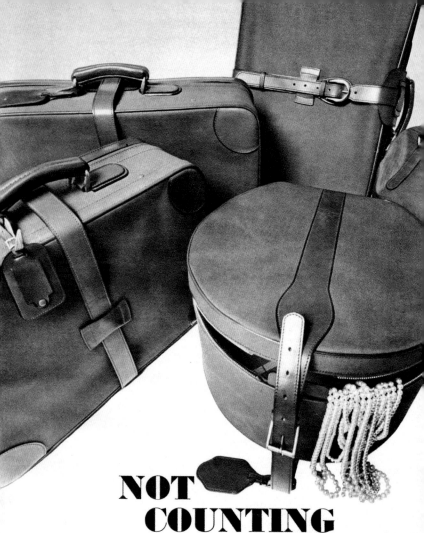

NOT
COUNTING
THE COST

Smooth travellers in the luxury class. Quintet of cases, rea
to take flight in royal blue canvas, brilliantly strapped in sca
leather, shiningly buckled in gilt. Three perfectly match
cases, stepped up in size. Impeccable hat box; light, flexi
holdall, side-locking. The set costs £114 18s. or the piec
can be bought separately. All by Gucci, New Bond St, Lond

Pearls: Jewelcraft. Photograph by Frank Whitch

AN EXPANDING EMPIRE

From the 1960s onward, the Gucci heirs were determined to capitalize on their father Guccio's legacy, and spread the family firm across the globe.

While Rodolfo and Vasco remained in Milan and Florence respectively, Aldo continued to run the operation in the US, where in 1960 the store had moved from New York's Savoy-Plaza Hotel to a prominent Fifth Avenue location. Following on from the London and Palm Beach openings, in 1963 Gucci arrived in Paris, and with Europe and the United States won over to the glamour of the Gucci label, Aldo began to look east for future expansion. In 1972 a store opened in Tokyo, with a larger flagship store opening in Hong Kong two years later. This was a lucrative period for the fashion house, as at the same time it was rapidly increasing its clothing component, opening a standalone boutique in New York dedicated to Gucci's clothing line.

During the 1970s, Rodolfo's son Maurizio had joined his uncle Aldo in New York, playing a large part in the running of the

OPPOSITE Since the very beginning Gucci had positioned itself as a luxury brand. As Aldo famously said: "Quality is remembered long after the price is forgotten". An advert from the 1960s illustrates this successful marketing strategy perfectly.

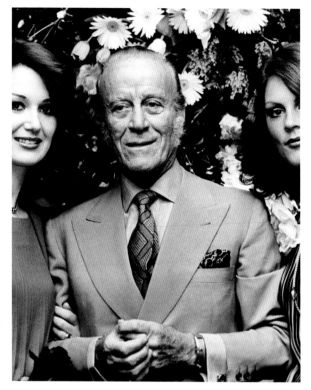

RIGHT Aldo Gucci, shown here at the opening of the London store in 1977, was the eldest of Guccio's sons and was dedicated to the firm his whole life, since joining in 1933. He was hugely instrumental in the global expansion of the brand both as a designer and businessman, opening stores in the United States and Far East.

company. However, with the advent of the new generation of Guccis, the label was soon to become notorious for its familial in-fighting, rather than just famous for its fashion credentials. First, in 1980, Aldo's son, Paolo, left the company to start his own fashion label under the name Paolo Gucci, leaning heavily on the 1966 signature Flora print for inspiration for his collection. Lawsuits were filed forbidding him to use the Gucci name and he was blocked. But in the fallout, Aldo himself was prosecuted in the United States for tax evasion, with Paolo testifying against his father until, eventually, in 1986 Aldo

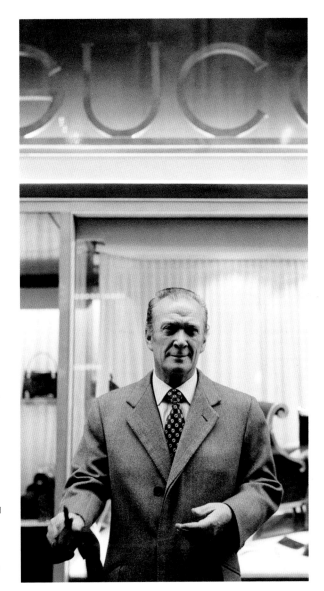

RIGHT Rodolfo Gucci, shown here in 1971 front of the Milan store where he was based, was also a major part of his father's firm, but as Aldo and Rodolfo's sons joined the company in the 1970s, family infighting started to threaten the brand's success.

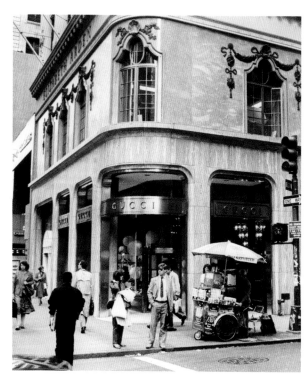

RIGHT Despite the brand's financial struggles, they continued to maintain the facade of success. The Gucci store on New York's Fifth Avenue, shown here in 1985, was one of the most prominent on the fashionable street.

pleaded guilty to non-payment of $7 million of tax money, earning himself a year's imprisonment. Meanwhile the death of Rodolfo in 1983 saw his son Maurizio grasp the leadership of the company for himself, first bringing on board a financial lawyer, Domenico De Sole, as president of Gucci America, and eventually ousting Aldo and his children, forcing them to sell their shares in the company. In retaliation Aldo accused Maurizio of forging his father's signatures on documents that transferred half of the company's shares to him alone. The company was floundering amid gossip and poor management.

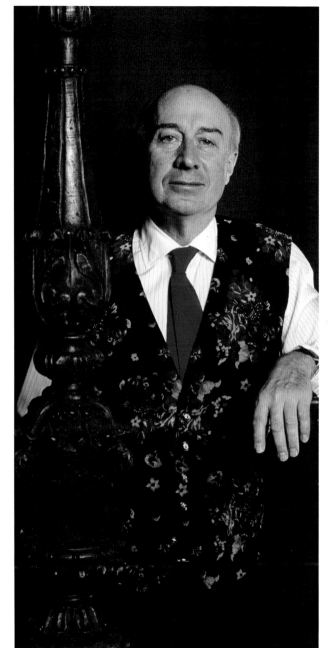

RIGHT In 1980 Aldo's son Paolo left the business to start his own fashion label, also called Gucci. His designs drew heavily on the signature 1966 Flora print, which led to legal action being taken by his father to stop him.

Despite showing the label's first ready-to-wear collection to great acclaim at the 1981 Florence fashion shows, Gucci's fortunes continued to wane during the 1980s. Maurizio had none of his father's or uncle's design flair or business acumen, and with the continued mud-slinging from the rejected members of his family, the reputation of the brand took a nosedive. Finally, in 1988, Domenico De Sole persuaded Maurizio to sell a large stake of the Gucci company to Bahrain-based investment bank Investcorp, taking control of Guccio's company out of the family's hands. With new investment, Maurizio brought on board Dawn Mello, an American fashion executive then working at Bergdorf Goodman. Mello immediately advised expanding Gucci's ready-to-wear business, widening the brand from just an accessories label. In order to do so, in 1990 she hired a young designer, Tom Ford. An immediate success, Ford became Design Director of all products within two years, but internal squabbles still dogged the brand. Maurizio finally liquidated his shares in 1993, with the company on the verge of bankruptcy after constant arguing with his partners about both business and artistic direction. In 1994 Mello left the company to return to Bergdorf Goodman. Ford took over as Creative Director and Guccio's heirs were no longer part of the fashion label that carried their name.

In a dramatic twist worthy of the worst stereotypes about Italian dynastic families, just 18 months after Maurizio divested himself of the last of his shares in the company, he was gunned down in the lobby of his elegant Milan offices. Suspicion fell immediately on his glamorous ex-wife Patrizia Reggiani, who had married Maurizio in 1972 and been catapulted into a life of glamour and celebrity as half of the famed "Gucci couple". With homes in Acapulco, Connecticut and St Moritz, a private yacht, and a luxury penthouse in New York, they fraternized

OPPOSITE The 1980s and 1990s were turbulent decades for the Gucci brand with Maurizio first selling the majority of his shares to investment bank, Investcorp, and finally leaving the company in 1993. Further scandal dogged the brand when Maurizio was gunned down in the lobby of his Milan office. Two years after his death his ex-wife, Patrizia Reggiani, was accused of hiring a hitman to kill him.

with the world's social elite including Jackie Onassis and the Kennedy clan. But Rodolfo's death in 1983, and the subsequent in-fighting and dramatic decline in the fortunes of the business – something Reggiani claims could have been avoided had Maurizio listened to her – damaged the marriage irreparably and the couple divorced. Three years after his death, Reggiani was convicted of hiring a hit man to murder him. In a 2016 interview in the *Guardian*, after her release from prison, she was quoted as saying about their relationship falling apart, "I was angry with Maurizio about … losing the family business. It was stupid. It was a failure. I was filled with rage, but there was nothing I could do."

Thankfully for the House of Gucci, under the dream team of Tom Ford and Domenico De Sole – or "Dom and Tom" as they became known within the industry – the brand reinvented itself, injecting glamour and sex alongside design expertise and a talent for the business of fashion. In 1995 De Sole made part of the company public, and both the profit and stock value of Gucci quickly rose. The final chapter in the saga of Gucci's ownership came in the late 1990s when first Prada, one of Gucci's direct competitors, then Bernard Arnault, chairman of the luxury goods mega-group LVMH, moved to purchase a controlling portion of Gucci shares. Horrified at losing control, De Sole brought in François-Henri Pinault, chairman of the retail giant PPR (Pinault-Printemps-Redoute), who bought a 40 per cent stake in Gucci. Positioning itself in direct competition with LVMH, the PPR group subsequently bought more designer brands including Yves Saint Laurent, Balenciaga and Bottega Veneta. By the end of the century, Gucci was the flagship name in a global luxury brands empire, with all the resources and power that brought.

OPPOSITE Gucci's association with equestrian sport included sponsoring polo events that were also tied in with the brand's aspirational image. Here Prince Charles holds his Gucci polo prize in Windsor in 1983.

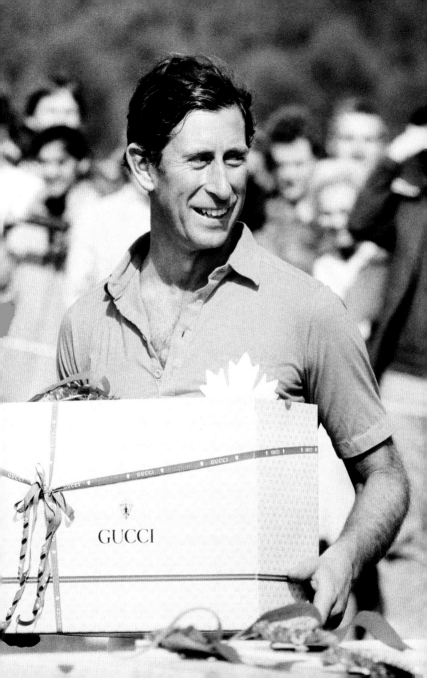

Tom
Ford

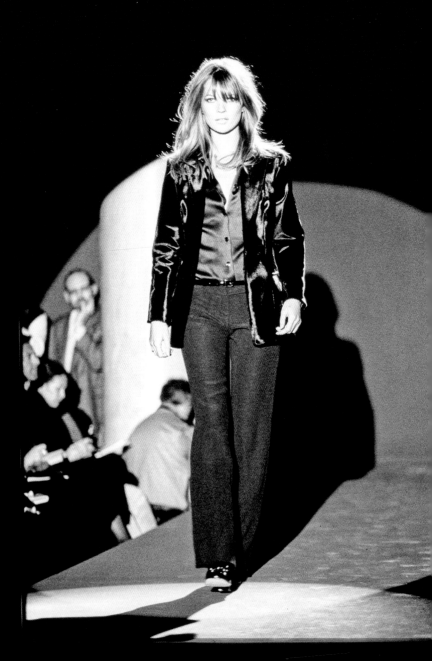

A SEXUAL
REVOLUTION

Today Tom Ford is recognized as one of the greatest fashion
designers of the past 30 years and is rightly credited with
turning around the fortunes of the Gucci label.

A t the time of his appointment to the ailing fashion
house by Dawn Mello in 1990, Ford had none of the
experience, credentials or reputation one might have
expected of a creative director of a major brand.

Born in Austin, Texas, in 1961, the young Tom Ford moved
to New York City in 1979 to study history of art at NYU
(New York University). However it was the social scene that
opened Ford's eyes to both a career within the fashion world
and the possibilities the city had to offer. In a later interview
with *Vogue* magazine, he remembered being invited to a
party: "Andy Warhol was [there], and he took us to Studio
54 – wow. Even today, I still start shaking when I hear
Donna Summer because it's the music of my coming of age."

OPPOSITE A young Kate Moss models a sensual, 1970s-inspired
outfit from Tom Ford's groundbreaking 1995 catwalk show.
The purple satin silk shirt, buttoned low and tucked into hipster
trousers with a slim Gucci belt, is topped with a matching velvet
jacket and patent, high-heeled Horsebit loafers.

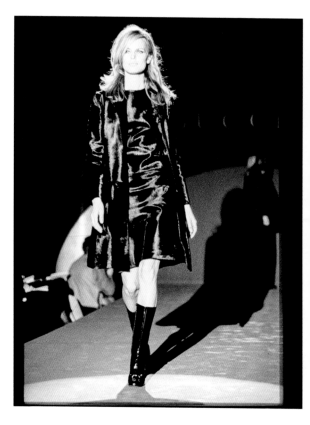

RIGHT Supermodel
Amber Valletta wears
a silk velvet dress
and matching coat as
part of Ford's Gucci
Autumn/Winter 1995
collection, which
inspired a trend for
head-to-toe velvet
and satin.

Studio 54 became a regular haunt of Ford's, where he mingled
with the likes of Halston, Bianca Jagger and Jerry Hall as well as
with Warhol himself, and the glamorous, sensual fashion styles
of this period formed the foundation of the Ford designs that
transformed Gucci's fortunes.

After a year of study, Ford dropped out of NYU to focus on an
acting career in LA. His good looks lead to castings in a number
of national advertising campaigns, experiences that later helped
him reshape the Gucci advertising strategy to great success.

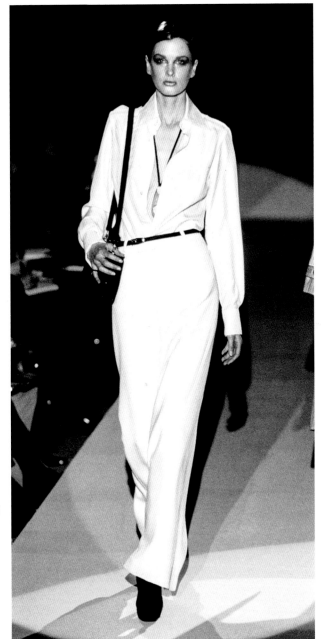

RIGHT Model Kylie Bax sashays down the catwalk in the Autumn/Winter 1996 collection. Her palely glamorous silk shirt is unbuttoned to the waist to reveal a statement gold necklace and matching flowing trousers have a Halston vibe that wouldn't have been out of place on Bianca Jagger in her Studio 54 days.

These early years as an actor sparked a lifelong passion for filmmaking, which became a second career for the designer in 2005 with the launch of his own production company, Fade to Black.

Returning to New York, Ford enrolled on an architecture course at Parsons School of Design. However, he quickly decided that he would prefer to pursue a career in fashion, selectively editing his resumé when he started to apply for fashion roles, by neglecting to specify the exact subject of his degree. Similarly, a stint in France as an employee of Parisian company Chloé found its way onto his CV, but Ford glossed over the fact that it was in fact a PR company and not the fashion label for whom he had worked. Through his persistence and ability to charm those he met, Ford eventually secured a position as design assistant to American designer Cathy Hardwick, who remembers his interview: "I had every intention of giving him no hope. I asked him who his favourite European designers were. He said, 'Armani and Chanel'. Months later I asked him why he said that and he said, 'Because you were wearing something Armani.' Is it any wonder he got the job?"

Ford worked for Hardwick for two years, until his appointment by Mello in 1990 to head up women's ready-to-wear at Gucci. While this might seem like a massive promotion for the relatively inexperienced young designer, it is important to remember that at the time virtually no one in fashion wanted to work for Gucci, let alone relocate to Milan, a condition of the role. As Mello explained, "I was talking to a lot of people, and most didn't want the job. For an American designer to move to Italy, to join a company that was far from being a brand, would have been pretty risky."

Nevertheless, Ford took the position and moved to Milan with his partner, fashion journalist Richard Buckley, a constant

support in his life. (They finally married in 2014, having been in a relationship for three decades.) In 1994, two years after his move to Milan, Ford's role expanded to include overseeing fragrance, advertising and the design of the Gucci stores, and when Mello left the company in 1994 to return to Bergdorf

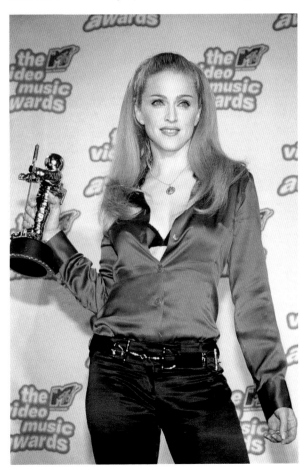

RIGHT Madonna was such a fan of Ford's breakaway 1995 Autumn/Winter show that she wore one of the collection's most recognizable outfits to that year's MTV awards. The turquoise satin shirt – unbuttoned to reveal the singer's bra – and Horsebit belt instantly sealed the new designer's reputation.

Goodman, Ford became Creative Director, finally stepping into the spotlight. With the unwavering support of President and CEO Domenico De Sole, Ford rapidly stamped his mark on the struggling brand.

The few reviews that Ford's debut collection in 1994 did receive were mixed, with hardly any fashion writers bothering to even watch the show. *Vogue* magazine's Sarah Mower remembers the Gucci publicist pleading with style journalists to attend his debut and yet, just one year later, the fashion crowd flocked to see Ford's groundbreaking Autumn/Winter 1995 collection. After the severity of 1980s power dressing, with its monotone colours and sharply-drawn lines, followed by early 90s shapeless grunge, Ford's louche, overtly sexual designs were an eye-opener. Drawing heavily on his experience at Studio 54 and the luxe-glam of 1970s styles, his designs included fitted satin shirts in jewel-like colours, unbuttoned almost to the waist on both men and women, paired with hip-hugging velvet bell-bottoms, velvet suits in electric orange and lime green, and richly textured coats of vivid blue. It was an assault on the senses, full of hedonistic indulgence in the form of luxurious fur, velvet, leather and satin, worn by models including Amber Valletta and Kate Moss, who sashayed sexily down the catwalk. Ford's collection was so new and bold that it has been widely credited with transforming the landscape of fashion.

Ford had not forgotten Gucci's heritage – the Horsebit loafer was still very much in evidence – but instead of playing it safe with the traditional values of the label, he had taken a brand which was essentially classic and blown it out of the water. A huge hit with the fashion press and high-profile celebrities including Madonna, who wore a key look from the collection to that year's MTV Music Awards, the charismatic Tom Ford had definitely arrived.

OPPOSITE Ford was the first of Gucci's head designers to incorporate an element of androgyny in his designs. Here a half-unbuttoned, fitted pinstriped blouse and matching trousers from his Spring/Summer 1996 show is an ironic nod to the pinstripe suits beloved of Wall Street bankers. Fittingly, costume designer Ellen Mirojnick confirms that she always put the character of Gordon Gekko from the *Wall Street* films in Gucci loafers.

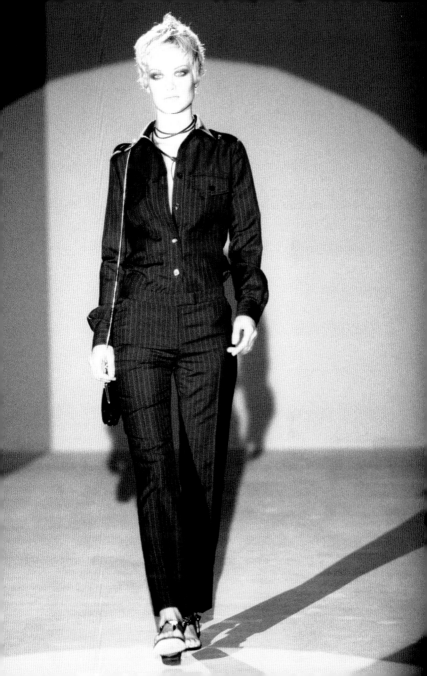

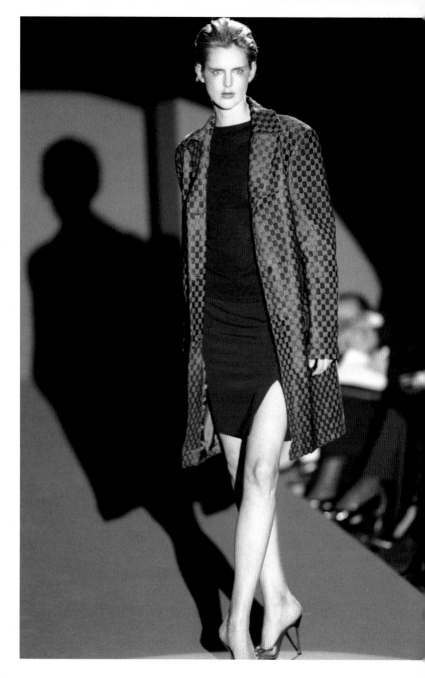

A year later, the designer acknowledged his 1996 Autumn/Winter show was when "it all came together for the first time". Ford's hyper-sexual designs, harking back to Studio 54 with a risqué Helmut Newton-style influence, shocked the world and was a welcome change for fashion's elite including Anna Wintour who, recalling Ford's appearance on the fashion scene, wrote in 2004, "When I think back to the early 90s, when he first arrived on my radar screen, fashion was buried deep in the shapeless layers of the horrible grunge look … Along came Tom with his low-cut hipsters and his slinky jersey dresses, and grunge was sent scurrying off back to Seattle."

Moving away from the previous year's collection and its celebration of disco colour, 1996 saw suits and jackets in monochromatic colours: sleek black leather and city pinstripe, or all white with neutral accents. The only exceptions were Ford's iconic velvet tuxedos, in red and deep blue. Coats were long and tailored, or otherwise oversized, and made from luxurious fur, and blouses were again slashed to the waist – a Tom Ford trademark – and tucked into hipster trousers, this time accessorized with would what become an iconic Gucci accessory, the skinny belt. Gold hardware was everywhere and became a feature that would be long associated with the brand. The evening wear section of Ford's show saw model upon model in slinky white jersey dresses with sexy cutout features, accessorized with gold belt buckles or with gold fastenings on the peepholes.

Despite the overt sexiness of Ford's designs there was still an androgynous element to his clothes, with similar tailored suits and velvet tuxedos created for both men and women, and all models wore the bottom-skimming hipster trousers. This early blurring of gender-specific dressing set a precedent for how the Gucci brand would evolve even after his departure, with his successors Frida Giannini and, in particular, Alessandro

OPPOSITE The interlocking-G motif was essential to the Gucci brand and all the label's head designers reworked it in their own style. This tailored coat, worn by model Stella Tennant for Spring/Summer 1997 over a fitted black dress accessorized with razor-sharp heels, is a perfect example of Ford's take on the logo.

Michele pushing the boundaries of androgyny and non-gender specific dressing much further.

As well as the clothes themselves, Ford's shows had a sense of theatre about them that enhanced the feeling that one was watching a louche nightclub scene. He used spotlights to pick out the models as they paraded down the catwalk, explaining that, "I decided to kill the backlighting and put the clothes under a spotlight because I wanted to control the room." Accompanied by a sensual soundtrack, the overall effect shouted "sex". During the following seasons Ford's designs became even more risqué, with models appearing almost naked in barely-there clothes, and in 1997 he famously debuted the Gucci G-string. Worn on the catwalk by almost-naked male and female models alike, the skimpy string underwear, held together by a metallic interlocking-G Gucci logo, was in fact a bikini bottom, but inspired a line of designer lingerie that is still popular today. (In 2018, Kim Kardashian posted an Instagram shot of herself in an original 1997 G-string, which gained her well over two million likes.)

Ford's collections, until he left the brand in 2004, built on his landmark 1996 offering, with 1997 and 1998 continuing to feature plenty of bare skin under navel-skimming satin shirts and cut-away sparkly tops, along with evening wear made from transparent fabrics topped by oversized glam-rock-colourful furs and sexy animal prints. By the end of the 90s, Ford was gradually starting to add more colour and flounces, harking back to the famous floral prints of Gucci's earlier heyday. But even in what might be called classic outfits, the skirts, tops and dresses were figure-hugging, slashed to the waist or semi-transparent, with logo G-strings peeking cheekily out from low-cut hip-huggers. In all of Ford's collections, the 1970s nostalgia was never far beneath the surface, and in his 2002 collection, models in oversized sunglasses and Halston-era gowns continued to channel the Studio 54 vibe.

OPPOSITE Jodie Kidd and Georgina Grenville model in the Gucci Autumn/ Winter 1997 ready-to-wear show. Both looks feature Ford's signature skinny belt.

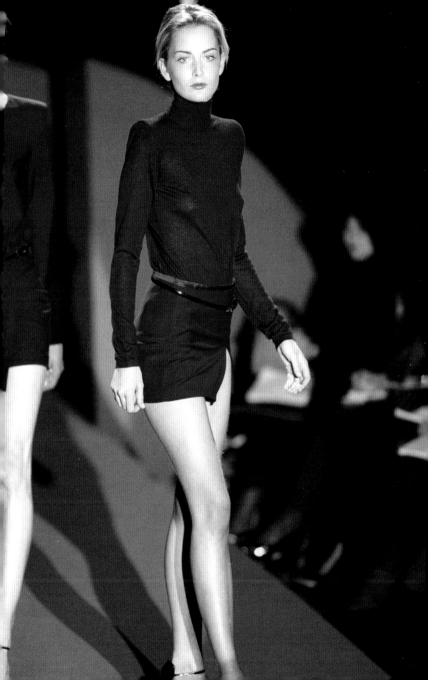

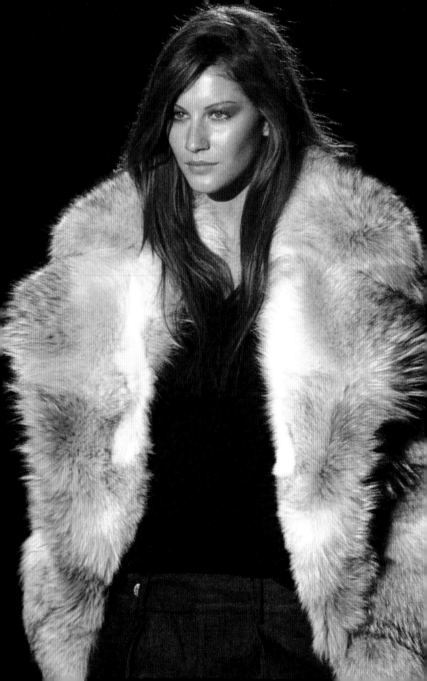

RIGHT By the end of the 1990s Ford was playing with a looser style of clothes but the sensuality always remained. These purple harem trousers, heavily embroidered with Swarovski crystals and worn sexily low on the hips, were such a statement that Madonna wore them to the 1999 Grammy Awards.

OPPOSITE Ford upped the aspirational glamour of the Gucci brand by using the hottest supermodels for his catwalk shows. Here Gisele Bündchen models a luxe fur coat for Autumn/ Winter 1999.

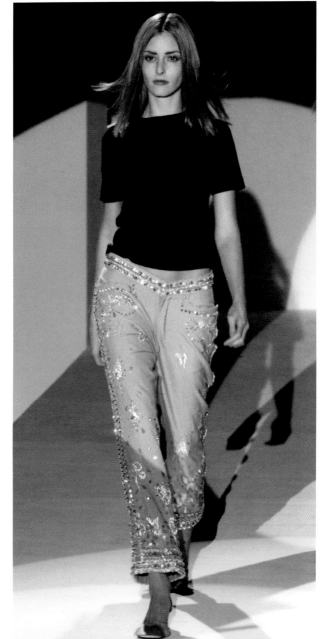

Ford's position as Creative Director of the whole of Gucci gave the brand a cohesive look that proved very successful. A large part of this came from the label's advertising campaigns, which Ford directed from 1995 onward in collaboration with photographer Mario Testino and stylist Carine Roitfeld. Roitfeld's particular brand of sexy European chic – which later saw her become the hugely successful editor of French *Vogue* – inspired Ford, who saw her as both a consultant but also a muse.

The advertising imagery that the team created began reasonably tamely with a campaign featuring model Amber Valletta, hip thrust out in a half-unbuttoned electric blue satin shirt and velvet

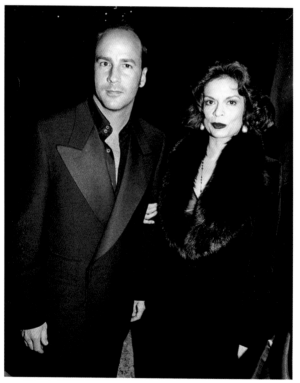

LEFT As a young man, newly arrived in New York in 1979, Ford became a regular at the famous Studio 54 nightclub, and 70s disco glamour was something that would continually influence his designs. Bianca Jagger, who epitomized the style of the club, became a longtime friend of Ford, seen here with the designer attending the CFDA Fashion Awards in 1997.

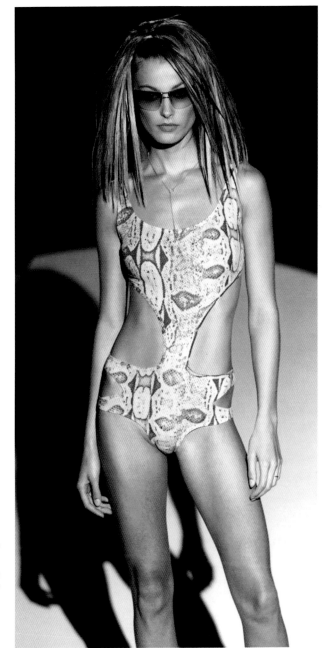

RIGHT Sex and
glamour will always
define Ford's
creations such as this
python-print cutaway
swimsuit worn by
model Aurelie Claudel
in the Spring/Summer
2000 show.

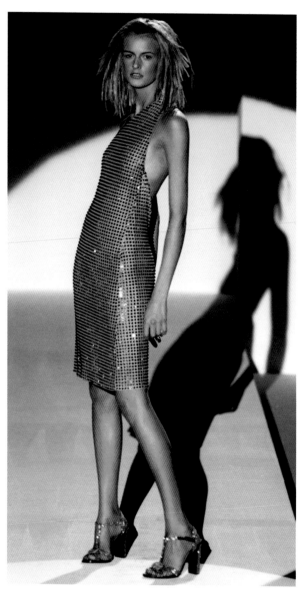

LEFT Model Jacquetta Wheeler wears a shimmering lilac asymmetric dress complemented with bright pink tights and strappy block-heeled sandals in Ford's Spring/Summer 2000 show in Milan. The collection marked a return to the designer's beloved 1970s disco glamour.

OPPOSITE Ford was never afraid to push boundaries, often with sexual connotations. This sportswear look, worn by model Jacquetta Wheeler for Spring/Summer 2000, pairs a bondage-style bikini top with side-slit silky running shorts and strappy high-heeled gold sandals.

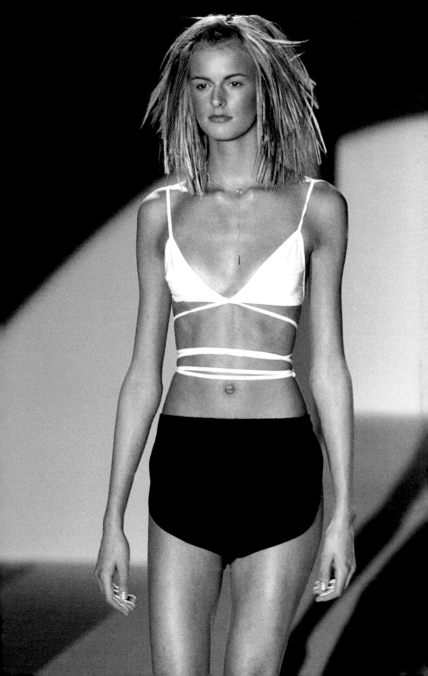

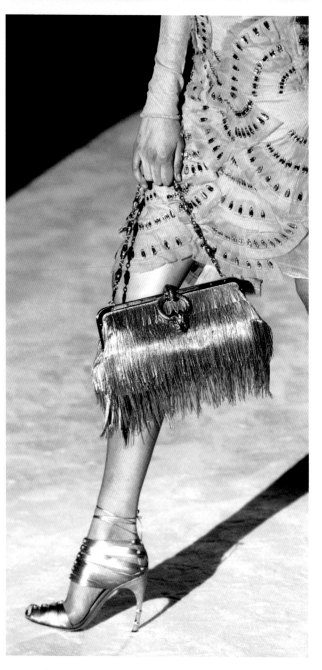

LEFT Accessories have always been essential to the Gucci story and by Spring/Summer 2004, Ford's penultimate collection for the label, the designer upped the decadence quotient, presenting luxury bags such as this fringed metallic evening bag with an emerald green serpent clasp.

OPPOSITE Expanding the sales of accessories was crucial to the success of Gucci, and Ford oversaw striking advertising campaigns all with a subtle edge that infused the brand with sensuality. This sunglasses ad is simple yet effective with the model's parted lips and the Gucci gold emblem becoming the focal points of the image.

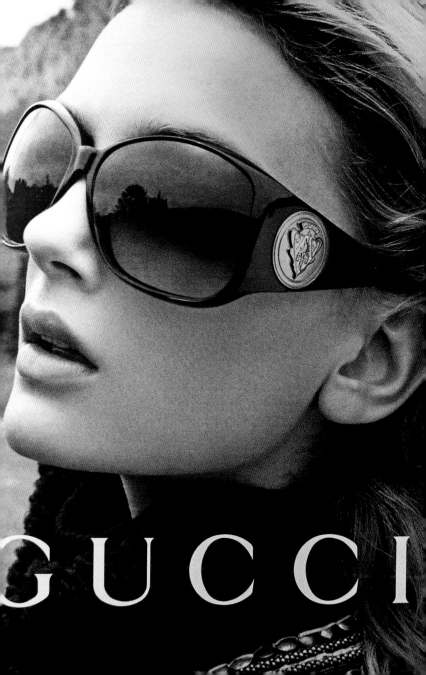

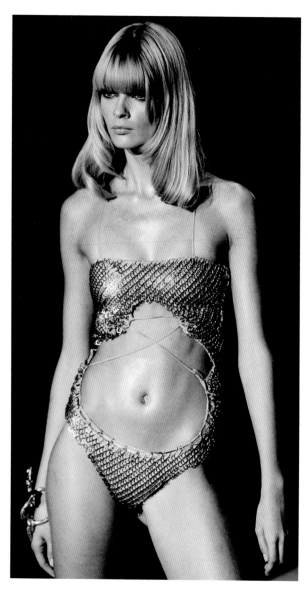

LEFT This deeply cutaway, bronze metallic chainmail swimsuit worn by model Julia Stegner for Spring/Summer 2004 is the kind of barely-there outfit that epitomizes Ford's love of slightly trashy glamour.

hipster trousers – the same outfit Madonna wore to the MTV awards that year. Backed by male models, the feel is sultry but nothing compared to the aggressively sexual, sometimes shocking campaigns that would follow.

For Gucci's fashion campaigns, big-name models including Georgina Grenville and Kate Moss appeared in various sexual poses, being groped by or posing entangled with male models. Nudity was commonplace, both for men and women; shirtless male models posed unbuckling their Gucci belts or, in lingerie ads, appeared lying face-down on the beach wearing nothing but the iconic Gucci G-string. And in 2003 Carmen Kass appeared pulling down her Gucci underwear in front of a male model to reveal pubic hair shaved into the Gucci G.

It is of course important to remember that in the late 1990s and early part of the 2000s there was no live-streaming of fashion shows, and the first glimpses of a designer's new collection would come from the advertisements in the fashion magazines' influential March and September issues. Ford pushed his team to the limits to create brand-defining images that reached new heights of creative accomplishment. In an interview with the *Independent* newspaper in 2008, Mario Testino recalled this era, explaining how "advertising campaigns became more exciting than editorial. When I started doing Gucci with Tom Ford, he pushed me to new heights."

Ford generated much debate with his use of controversial advertising for Gucci and also for Yves Saint Laurent, which was by then owned by the Gucci group and with Ford also designer-in-chief. Some ads were so controversial that they were banned by the UK's Advertising Standards Authority – most famously the 2000 Yves Saint Laurent Opium fragrance advertisement featuring a nude Sophie Dahl reclining provocatively, eyes closed and wearing nothing but gold stilettos and jewellery, again styled by Carine

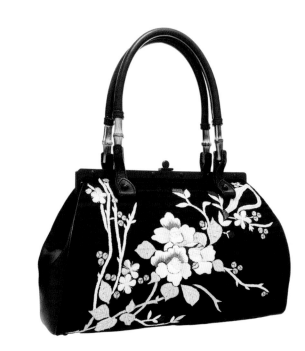

RIGHT This elegant black satin frame bag designed by Ford encompasses many of Gucci's heritage motifs including the bamboo handle and floral pattern.

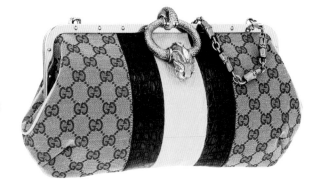

RIGHT Ford played with the traditional Gucci stripe, experimenting with different colourways including this striking purple and yellow alligator version with enamel dragon closure and bamboo strap.

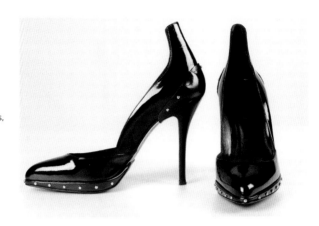

RIGHT These patent black leather spike heel shoes with studs, designed by Ford in 2003, hint at the powerful dominatrix that so often lurks beneath the outfits in the designer's collections.

Roitfeld. The tactic might have aroused much criticism but, as they say, there is no such thing as bad publicity, and there is no denying that it worked. This was an era when achieving bodily perfection became as much a status symbol as wearing the latest designer label, and Ford managed to fuse the two ideals to make Gucci irresistible to a new generation of shoppers.

When asked in an interview to sum up his legacy for Gucci, Ford replied, "I think I brought back hedonism, a certain kind of ostentatious fashion … a certain sexual glamour." This raw sexuality dramatically increased the appeal of the Gucci brand, coveted not just for its iconic accessories but for its clothes too. And the strong celebrity associations with the brand, thanks to Ford's magnetic personality and social cachet, helped. In an interview with fashion critic Bridget Foley, Ford explained, "Madonna went out in our hip-huggers and our loafer sales went up. Now, here were pinstriped suits that started to sell, that everyone from 30 to 70 could wear. I am a commercial designer and I am proud of that; I have never wanted to be anything else. This gave other people an inkling of what I always knew – that we could really sell clothes."

In 2004, having resurrected the Gucci brand and built an empire that now included Yves Saint Laurent, Balenciaga and Bottega Veneta – plus recent acquisitions of young and exciting designers Stella McCartney and Alexander McQueen – Domenico De Sole left the brand, intending to retire. Ford was earmarked as his successor as CEO, but in a surprise move the designer announced he was also leaving. Rumours surfaced of a rift between Ford and luxury goods conglomerate PPR, which had a controlling stake in the Gucci Group, with PPR claiming Ford wanted too much money. But the designer denied the charge, instead telling *Women's Wear Daily* that "money had absolutely nothing to do with it at all. It really was a question of control." Regardless of why he left, the split was acrimonious to the extent that when the Gucci Museum opened in Florence in 2011, Ford's legacy was strangely diminished, with some exhibits not featuring his work at all. It was only in 2016 after Alessandro Michele, a huge admirer of Ford, took charge of the brand that Ford's massive contribution to the story of Gucci was included.

After leaving Gucci, Ford started his own eponymous label, luring his long-time business partner De Sole from retirement to become chairman of Tom Ford International. The dream team was back in action and Ford's new venture proved as successful as his tenure at Gucci. Meanwhile the role of head of creative design at Gucci was taken over by Frida Giannini, who had worked for alongside Ford at Gucci for two years and who – along with her husband Patrizio Di Marco, who first headed up Bottega Veneta before becoming CEO of the Gucci Group in 2009 – took the label forward.

OPPOSITE Over the last few decades Gucci has actively supported a number of charitable causes through fashion shows and one-off garments. Ford has always been an ardent campaigner for AIDS charities and in 1997 posed for a series of portraits in support of the annual Los Angeles AIDS Project gala.

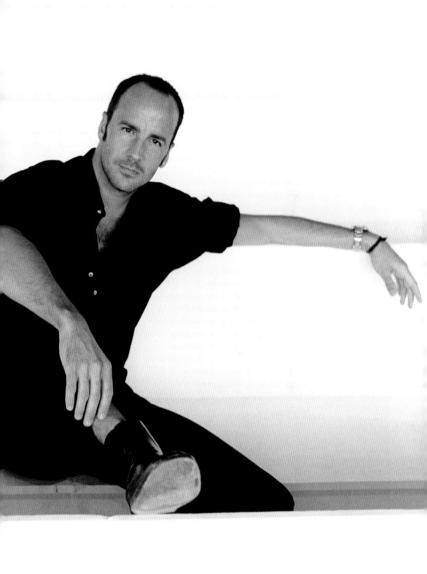

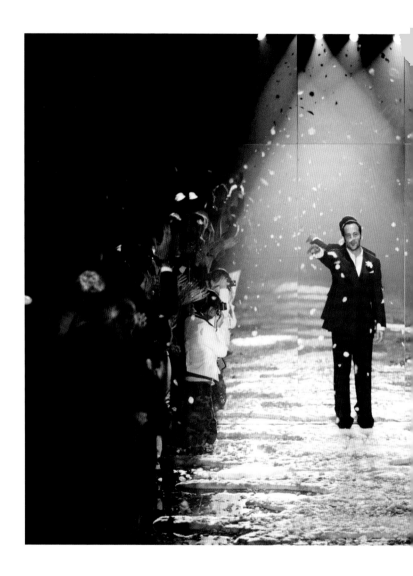

LEFT In February 2004 Ford takes the applause at his emotional last show for Gucci. His departure marked the end of a defining era for the house.

Frida
Giannini

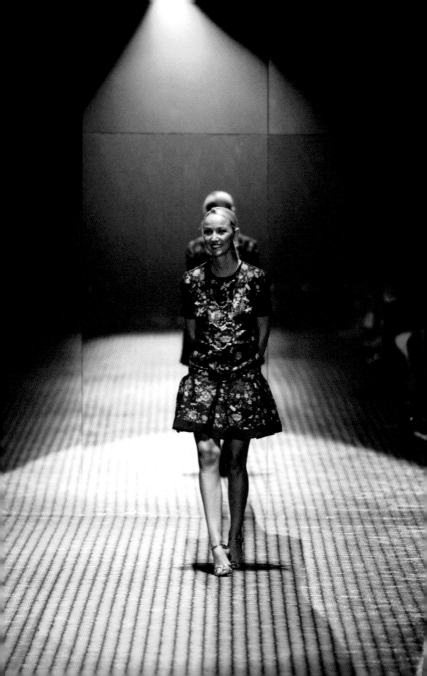

A STREAMLINED GLOBAL BRAND

Frida Giannini is in many ways the quintessential modern Gucci woman. Impeccably groomed, slim, with long, honey-blonde hair, sharply parted at the centre, Giannini is sexy but understated, with a sophisticated style that favours fitted black dresses, elegant trousers and silk tops, paired with Gucci's strappy sandals.

Born in Rome in 1972, her father was an architect, her mother a professor of art history and, as a middle-class Italian girl growing up in the 1980s, she was part of a pivotal generation. When asked about her influences as a young woman, she cites a wide variety including the sexy romance of Fellini's *La Dolce Vita*, the glamour and gender fluidity of David Bowie, and the nostalgia of *Breakfast at Tiffany's,* all of which were reflected in different ways during her decade-long tenure as head of Gucci. As part of the pre-internet generation, she understood analogue, yet was nevertheless primed to embrace a new world of digital fashion and social media while always acknowledging the importance of a brand's heritage.

OPPOSITE In many ways Giannini embodies the Gucci ideal, always perfectly groomed and elegantly dressed. Here she walks the runway after her Spring/Summer 2007 show wearing one of the Flora printed dresses from the collection.

After studying at the Academy of Costume and Fashion in Rome, Giannini joined the Italian fashion house Fendi in 1997, where she worked on ready-to-wear for three seasons before being promoted to the design of leather goods. Her time at Fendi coincided with the launch of the wildly successful Baguette handbag, one of the first it-bags and one of the products that made Fendi so attractive to the luxury giant LVMH, which subsequently bought the family-run firm. In 2002 Tom Ford hand-picked Giannini and brought her, aged just 24, to Gucci, where she worked as head of design for handbags and accessories until 2004. Ford's abrupt departure saw Giannini promoted to head of accessories, alongside Alessandra Facchinetti who oversaw womenswear, and John Ray who took control of menswear. Just two years later, after an unremarkable couple of collections by Facchinetti, who left in 2005, Giannini took over both womenswear and menswear, as well as store design and all advertising and communication, giving her almost total creative control of the Gucci brand.

After the massive commercial and creative success Ford had achieved during his years at the helm of Gucci – along with the fact he was a fashion celebrity compared to the barely known Giannini – the pressure was on, and it took several years for the young designer to make her mark. For her 2006 Autumn/Winter collection, Giannini seemed to be mimicking Ford with a glam-rock collection full of the 1970s inspired shapes and throwback 90s metallic accessories – including platform shoes with the identical "car paint" high-shine finish that Ford had used in his first collection. Looking more closely, however, Giannini's own influences, notably that of David Bowie and his boundary-pushing sense of style, were beginning to surface. "I was thinking of David Bowie and the way people played with their image to be something different every time they went out in the 70s," she said.

RIGHT & ABOVE One
of Giannini's biggest
successes was the
relaunch of the Jackie bag
labelled the New Jackie,
shown here in both classic
tan leather and Giannini's
relaunched Flora print in
purple leather and canvas.

LEFT Simple elegance is one of the defining characteristics of Giannini's design, exemplified here in this outfit from Pre-Fall 2010 comprising a brown silk top and tailored wide trousers with tan coat and matching accessories.

OPPOSITE For Gucci's 70s-inspired Autumn/Winter 2011 collection Giannini cited Anjelica Huston as an influence, taking the brand straight back to the Studio 54 days of Ford's collections. Here Joan Smalls wears a flowing turquoise chiffon gown with textured floral stole.

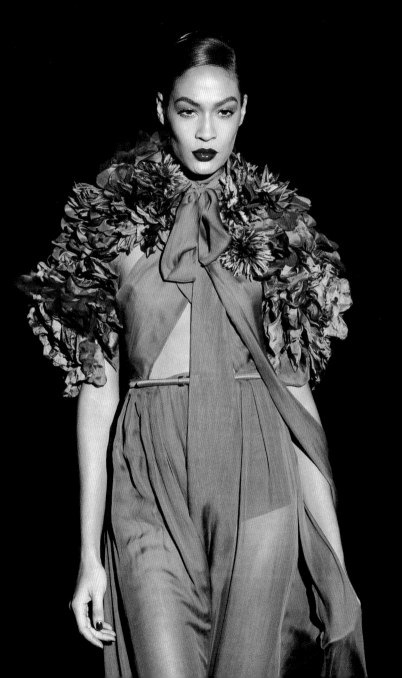

The show was in marked contrast to the many other designers showing in Milan that season, where a new restrained and sombre mood prevailed. But the party was still going strong at Gucci, with plenty of glitzy gold and purple, oversized fur, and sequin-covered fabrics. Reviews, however, were mixed, with fashion commentators unsure whether they liked the label's new creative head.

But by the following year Giannini was beginning to move away from Ford's super sexed-up 70s disco-fever designs, and was instead beginning to look back to Gucci's heritage for womenswear as well as accessories, something that would become a trademark of her leadership of the brand. For the label's 85th anniversary, the designer explained, "I've been thinking about the early 60s, and a few things from the archive." Although *Vogue's* Sarah Mower opined that the collections was less about honouring Gucci's heritage and more about trying to increase the brand's appeal to a younger audience, especially with a random scattering of folksy, girly dresses. Mower further criticized the lack of cohesion in the show as a whole, complaining that "Giannini needs to learn what's for retail racks, and what makes a concise statement in a show".

As the last few years of the decade progressed, Giannini began to noticeably pare down the flounces and ethnic, bohemian accents that had permeated her 2007 and 2008 shows. She presented a carefully curated set of outfits from which *Vogue* deduced that "Frida Giannini is from a different generation than Milan's other female designers, and she sees fashion from a more pragmatic standpoint. Gucci now is a clearly segmented, businesslike collection with no pretence of being anything other than hip, immediately understandable clothes for a young global audience."

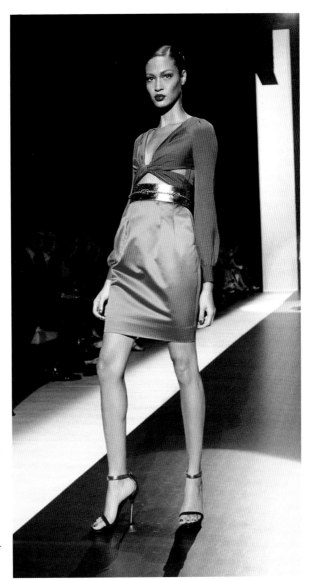

RIGHT Though often criticized for changing direction too suddenly, Giannini ignored critics and stuck to her guns. Here model Joan Smalls wears an outfit from her Spring/Summer 2011 collection full of colour blocking in bold, fresh colours.

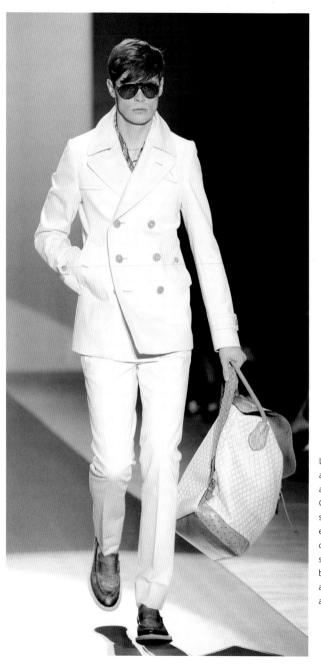

LEFT Menswear is just
as important to Gucci
as womenswear, and
Giannini always offered
subtly fashionable,
expensive-looking
classic Italian designs
such as this double-
breasted white suit
accessorized by loafers
and sunglasses.

RIGHT The Gucci Guccissima embossed leather pattern, shown here on a laptop bag, was designed by Giannini in 2006 and has become a modern classic.

Giannini's strength has always been knowing Gucci's clientele, and in this 2009 collection she exhibited how her priority was to cover all her customer bases. Streetwear was offset by delicate party dresses, and tropical-print shirts sat beneath sharply tailored, boyish suits. This narrow silhouette was named the "Frida" and the slim-cut trousers have become another Gucci signature. The new, focused collection coincided with Giannini moving Gucci's design studio from Florence to Italy's livelier capital, Rome, her home city and one she felt better represented Gucci's new ethos. "Florence is such a small city. The guys in my team, they are young, they need to go out, meet people. Rome has beautiful light, friendly people, a wonderful lifestyle."

Similarly, the Gucci boutiques, also under Giannini's remit, were redesigned as wide, open spaces, filled with natural light, warm wood, and amber glass fixtures and fittings. The stores, like the brand, blended modernity with heritage, projecting status and luxury but also a cool, hip youthfulness.

As the decade turned, Giannini grew in confidence. While retaining the sensuality of Ford's era, so essential in redefining the Gucci brand, Giannini gradually abandoned the overt sexuality and louche hedonism that so defined Ford's collections. Her Spring/Summer 2010 collection went in a new modernist direction with an almost sci-fi edge. White multi-strap and cutaway dresses and mesh tops had a bondage vibe that Ford would have been proud of, but the overall effect was cleaner and bolder, with a feminist assertiveness. As always, heritage accents abounded, with large belts fastened by a variant on the Horsebit and, most importantly, the handbag of the season, a reworking of the old hobo bag named for Jackie Kennedy, now labelled the "New Jackie".

Originally an accessories designer, Giannini has contributed hugely to the evolution of the Gucci it-bag by reworking classics from the label's archives into new, fresh designs. One of her earliest successes was with Gucci's iconic Flora print, first commissioned by Rodolfo Gucci for Grace Kelly in 1966. Giannini resurrected it in 2004, producing a range of vibrantly colourful yet nostalgic canvas bags, which hit the stores as part of the 2005 Cruise collection. The Flora had been somewhat forgotten alongside the other heritage motifs so prevalent on Gucci accessories: the double-G fastening, the Horsebit embellishment and the green–red–green woven stripe. Although Ford had used elements of floral design in some of his later collections, it was Giannini who revived the actual Flora pattern, cementing its importance. Since then Giannini has constantly revisited the print, on handbags, scarves and clothing, naming a fragrance after it in 2009, and even using it for menswear in her Spring 2013 Resort collection.

In 2006 Giannini designed another instant classic in the form of the Gucci Guccissima. Literally translating from Italian

OPPOSITE The throwback to the seventies for Autumn/Winter 2011 led to some of Giannini's most memorable designs, including this striking belted fur-trimmed suede coat.

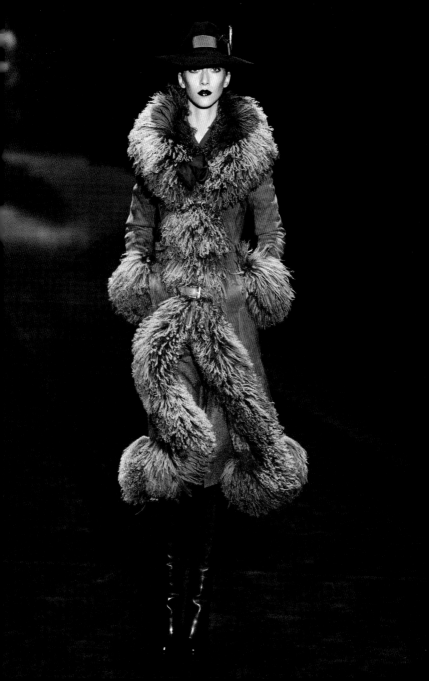

as "most Gucci", this version of the original double-G print was embossed onto butter-soft leather and became one of the designer-label-obsessed 2000s' most popular logo bags, rivalled only by the updated "New Jackie" bag in 2009 with its instantly recognizable slouchy style. Similarly, Giannini's final collection for the fashion house, Spring/Summer 2015, saw the Bamboo handbag and the Gucci stripe all given the Frida makeover, with yet another modern twist on the psychedelic 1970s.

It was this skill, raking the archives for Gucci classics and updating them for a new audience, that so defined Giannini's time as designer-in-chief. And for the most part it worked, even if she will not be remembered as a designer as exciting as either Ford before her, or her successor Alessandro Michele. In an interview with *Dazed* magazine in 2012, Giannini was asked what she felt defined contemporary Italian fashion and her answer succinctly sums up her approach to design at Gucci: "Duality: the ability to look ahead without losing sight of the past."

The 2011 show, marking Gucci's 90th anniversary, saw a massive injection of the label's old glamour. Citing Studio 54's finest, Anjelica Huston, as one influence, Giannini also named Florence Welch of Florence and the Machine as her muse. (Gucci designed many of the outfits Welch wore on tour and the singer subsequently became an ambassador for the brand under Michele.) The collection, firmly back in the 1970s, was a riot of unexpected colour and texture: aquamarine, scarlet, citrine, burgundy and violet joined velvet blazers, fur-collared coats and feather-trimmed fedoras, with just a little bit of traditional Gucci sex appeal in the shape of a slim, black pencil skirt. Evening wear was made up of long, draped chiffon gowns, the inspiration for which the designer

OPPOSITE Music has always been a huge inspiration to Giannini, who has a personal collection of over 8,000 vinyl records. Here she is pictured with musician Nick Rhodes at a private dinner in New York in 2007 where Mariah Carey and Jon Bon Jovi were also present. The designer was so thrilled to meet the Duran Duran singer that she even serenaded him with one of the band's hits.

attributed to Florence Welch, although, as *Vogue* pointed out "they wouldn't have looked out of place on Angelica circa 1970-something, either".

Of course, music has always been important to the Gucci brand, both as part of the staging of shows and through associations with pop stars such as Madonna, but for Giannini, who admits to a personal collection of over 8,000 vinyl records, it is an inspiration, "Music, much like film, is such a vibrant part of today's culture: It frequently provides inspiration for my work."

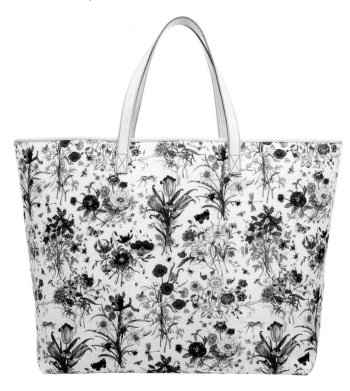

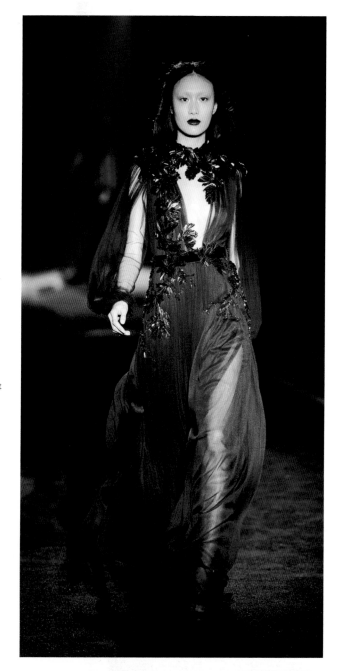

RIGHT China is fast becoming another lucrative new market for Gucci and other aspirational brands, and in April 2012 Giannini staged her first show in Shanghai.

OPPOSITE Giannini is credited with resurrecting the 1960s Flora print and bringing it to a modern audience. This large canvas tote bag is a beautiful example.

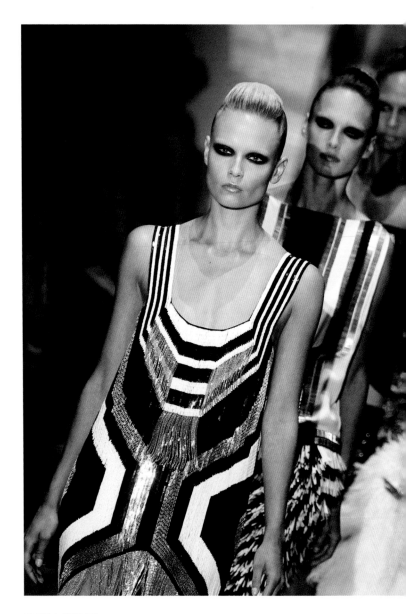

LEFT Giannini's
Spring/Summer
2012 show, full of
beautiful architectural
shapes inspired
by the Chrysler
building of the 1920s,
coincided with the
90th anniversary of
Gucci. However, the
designer insisted that
her art deco-inspired
collection had nothing
to do with the 1921
founding of the brand.

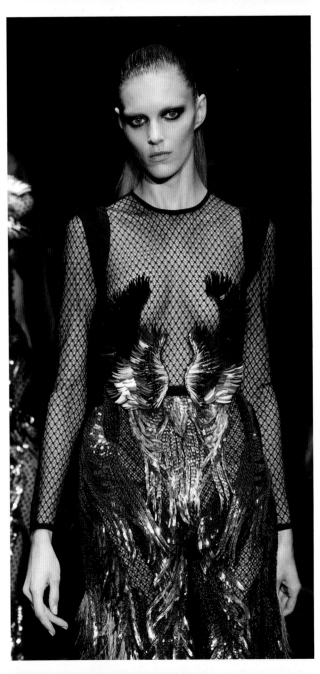

LEFT For her Autumn/ Winter 2013 show Giannini sent models down the catwalk in gloriously embellished evening gowns full of sequins and feathers in wing motifs on top of black mesh. The sensual glamour harked back to the days of Ford.

OPPOSITE Giannini's strong relationship with UNICEF included appointing the singer Rihanna to star in an advertising campaign to benefit the charity. Here the designer is shown with Madonna and Rihanna attending the launch of the Tattoo Heart Collection by Gucci in New York in 2008. Twenty-five per cent of the proceeds from the collection went to the charity.

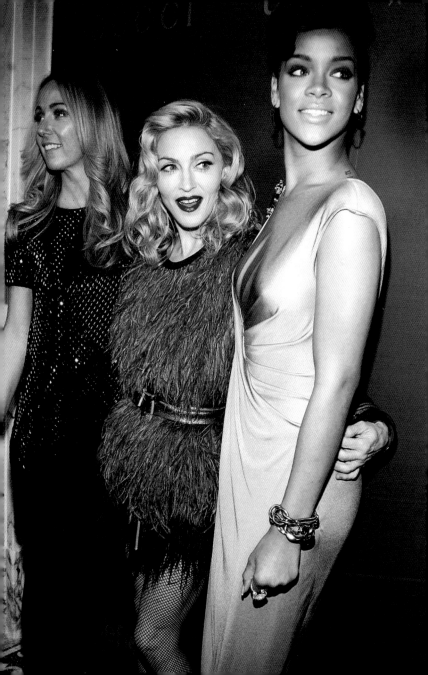

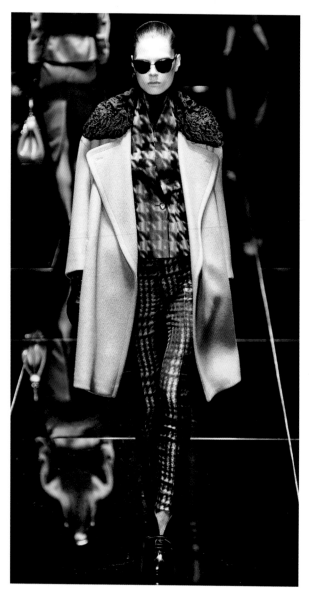

LEFT The retro feel in Autumn/Winter 2013 was heightened with clothes as skin-tight as Ford would have designed them, including this houndstooth waistcoat and trousers in black and powder blue, with oversized jacket with sunglasses completing the power-woman look.

OPPOSITE Giannini's focus on keeping every bit of Gucci's customer base happy led to some reviewers saying that her shows lacked cohesion. In Spring/Summer 2013, however, she expertly managed the balance, offsetting colourful daywear with monochrome evening wear such as this striking dress.

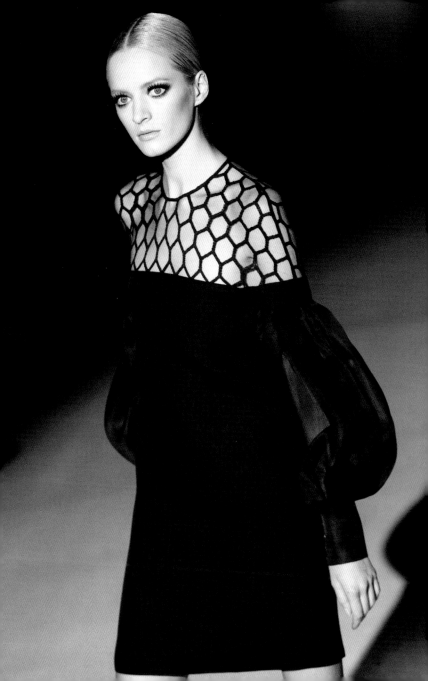

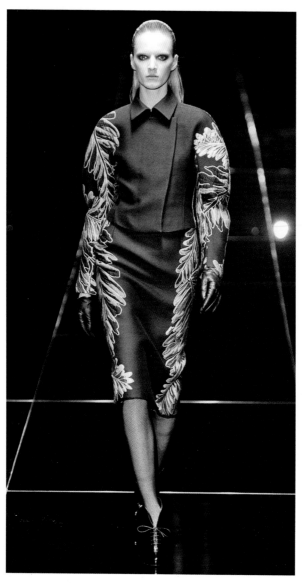

LEFT A big fan of floral prints in general, Giannini frequently used the motif in her designs as shown here in this black suit patterned with oversized pink and purple leaves.

From David Bowie's Ziggy Stardust to Eugene Hütz, the frontman for gypsy punk band Gogol Bordello, whose Cossack style permeated Giannini's 2008 and 2009 menswear shows, musicians both inspired and collaborated with the designer. In 2008 singer Rihanna performed at a New York Fashion Week Gucci–UNICEF fundraiser. Shortly afterward, Giannini announced that the global superstar would be appearing in an advertising campaign to benefit the charity, wearing limited edition Gucci designs that would be sold, with 25 per cent of sales going to UNICEF. This connection to the world of music and its stars would continue during the next decade as Giannini handed over the reins of Gucci to Alessandro Michele.

Giannini's final few years at Gucci included overseeing the opening of the Gucci Museum at the end of 2011, showcasing not only iconic pieces from the House of Gucci's archives but also work by contemporary artists, as well as a series of breakaway collections including her 2012 Spring/Summer show with its art deco theme and strong, architectural shapes. Colours were monochromatic black and white, or sharply-drawn blocks of green, mustard and white. It was a departure for the designer, but, as always, the collection was eminently wearable off the catwalk, too.

Giannini has always blended the old and the new at Gucci – her final few collections included revisiting the 60s and 70s as well as offering for Autumn/Winter 2014 a pared-down and less overtly glamorous collection. The press were mixed in their opinions, but Giannini was philosophical when she reflected on her critics, in a *Guardian* interview in 2011: "For winter I did 70s and it's 'too much from the archives', and then for summer I did 20s and people say 'she's forgotten about the archives'. Believe me, it can be frustrating … But you

can't listen too much. I have a strong point of view, and it's important that I fight for my ideas."

It is this strength of character, and determination to push through regardless, that marked Giannini's leadership of Gucci alongside CEO Patrizio di Marco, with whom she started a romantic relationship when he joined Gucci in 2008. Creatively, both in her collections and for Gucci's advertising campaigns, she has been accused of playing it safe, taming the in-your-face sexuality of Ford and preferring to rework the past. "The Gucci of di Marco and Giannini is more intent on rediscovering its traditions than creating scandal," wrote Italian journalist Daniela Monti.

The relationship of Gucci's designer-in-chief and CEO has partly been blamed for the brand's declining sales which eventually led to both di Marco and Giannini leaving the fashion house. Rumours that other members of the design and business team felt sidelined and kept in the dark when key decisions were being made, culminated at the end of 2014 when di Marco left involuntarily. A leaked staff memo obtained by the *New York Times* made it clear that the businessman did not want to go and blamed enemies within the company for forcing him and Giannini out: "Against my will, I leave my cathedral uncompleted. It's a pity I won't be able to see how this beautiful story would have continued." (The power couple had a daughter in 2010 and finally married just a few months after being ousted from Gucci, Giannini seeming to deliberately snub her former employer by choosing a Valentino dress.)

Although Giannini was given the chance to stay and see her final collection onto the catwalk in February 2015, she departed in January, leaving head of accessories Alessandro Michele just a week to pull together the menswear collection.

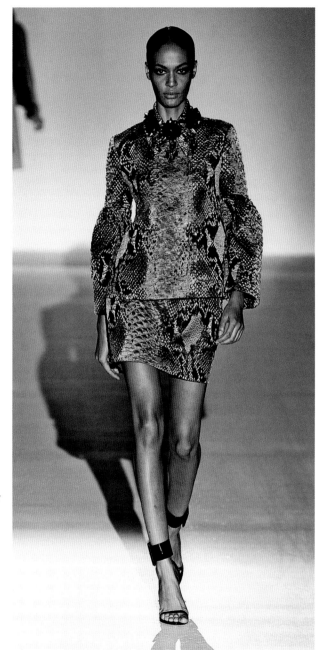

RIGHT Giannini has rightly been called a very Italian designer, exemplified in her Spring/Summer 2013 show where Riviera colours mixed with 60s prints, all perfectly coordinated with matching accessories and oversized sunglasses, could have come straight off the backs of Europe's original jet set.

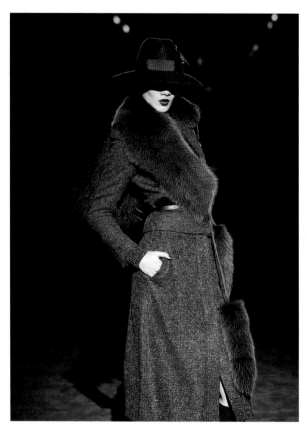

LEFT Global expansion into Asian markets has seen Gucci grow to be one of the world's leading luxury brands. This film noir outfit accessorized by glamorous fur stole and fedora-style hat was part of a collection showcased in Seoul in 2011.

OPPOSITE For the Spring/Summer 2013 menswear collection Giannini offered a similar 60s Italian Riviera lifestyle look complete with patterned jacket, white chinos and Gucci Horsebit loafers, worn barefoot of course.

Again, surprising the fashion world, the relatively unknown Michele was announced as Giannini's successor, with Anna Wintour commenting shortly after meeting him, "He was eccentric, a little bit eccentric, but charming." Her words could not have been truer, and over the coming years, Gucci would be transformed once again under the patronage of Michele's wild and flamboyant genius.

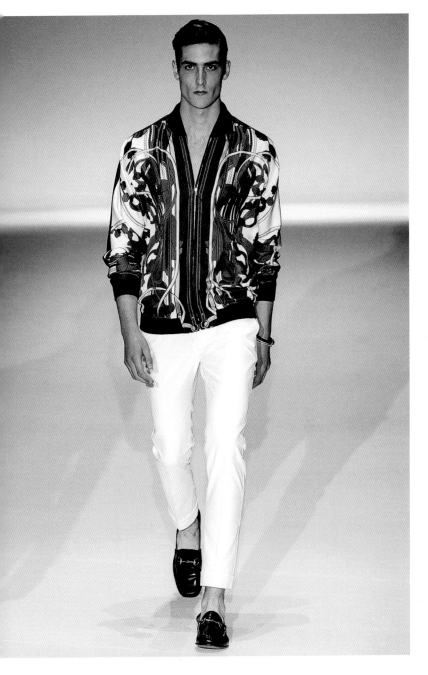

Alessandro Michele

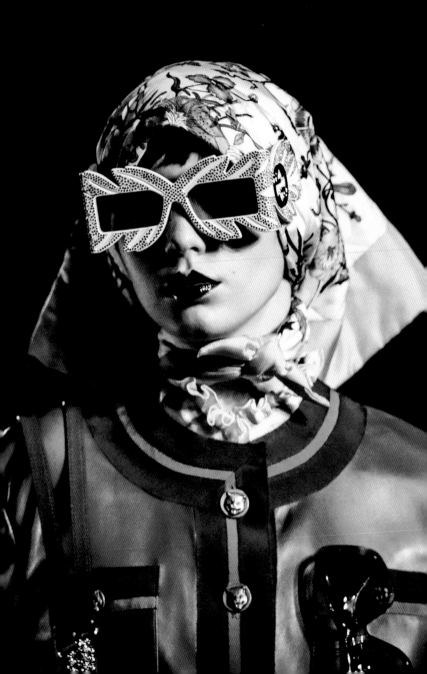

A
FASHION
VISIONARY

"Those who are truly contemporary are those who neither perfectly coincide with their time nor adapt to its demands … Contemporariness, then, is that relationship with time that adheres to it through a disconnection."

*– Italian philosopher Giorgio Agamben,
quoted in notes left on the seats at
Alessandro Michele's debut show*

A t the beginning of 2015, after the ousting of designer-in-chief Frida Giannini and her partner, CEO Patrizio di Marco, Gucci was struggling. Sales had slumped, and Giannini's tactic of producing clothes and accessories to please every possible Gucci customer had seemed to backfire, creating the general consensus that the brand had lost direction. Added to this was the overall zeitgeist, which by 2015 was less about conspicuous consumption and status symbols and more about a subtle anti-consumerism. Luxury brands could no longer count

OPPOSITE A look from Alessandro Michele's Resort 2019 collection, shown in the Alyscamp burial ground in Arles, France. Show notes described the models as "widows attending grave sites, kids playing rock 'n' roll stars, and ladies who aren't ladies."

on an ostentatious logo being enough to sell their products, and Gucci's competitors were already relying more on their creativity and craftsmanship than just their names.

As was the case in the 1980s, before Tom Ford arrived at Gucci, the brand was in dire need of a change of direction and a fresh eye. Various contenders were mentioned in the fashion press, including Riccardo Tisci and Peter Dundas from rival luxury goods conglomerate LVMH, and British stylist Katie Grand, who had been brought in by Giannini to stage the Spring/Summer 2015 collection in a last-ditch attempt to up the hip quotient. Even Ford was in the mix, although his return to the fashion house was always unlikely. But to everyone's surprise the job was given to Alessandro Michele, a man little known outside the company, who was currently working as Giannini's associate designer.

The appointment was made by new CEO Marco Bizzarri, rumoured to be the one to have fired Giannini, who he found it hard to get along with. Bizzarri, who had previously worked as CEO at Stella McCartney and Bottega Veneta, definitively rejected Giannini's overemphasis on the past, saying in a 2018 interview for *Fast Company* magazine, "The company was really losing speed and was a little bit dusty. There was too much emphasis on heritage. I wanted to move the company to be more inclusive, more joyful, full of more energy."

Bizzarri could not have chosen better – there are few individuals who epitomize joy and energy more than Michele – and although acknowledging that heritage was still important, it needed to be instinctive rather than through the meticulous scouring of the label's archives. Gucci needed a designer who could become the physical embodiment of the brand and Michele fit the bill. As Bizzarri explained, "Why should I look for someone else when he can translate the heritage – and when the values of Gucci are in his veins?"

OPPOSITE Michele's debut collection for Gucci was menswear Autumn/Winter 2015, which he completely redesigned in just five days after Giannini's sudden departure. From the very beginning the designer blurred gender boundaries, opening the show with long-haired model Hugo Goldhoorn wearing a red silk pussy-bow blouse.

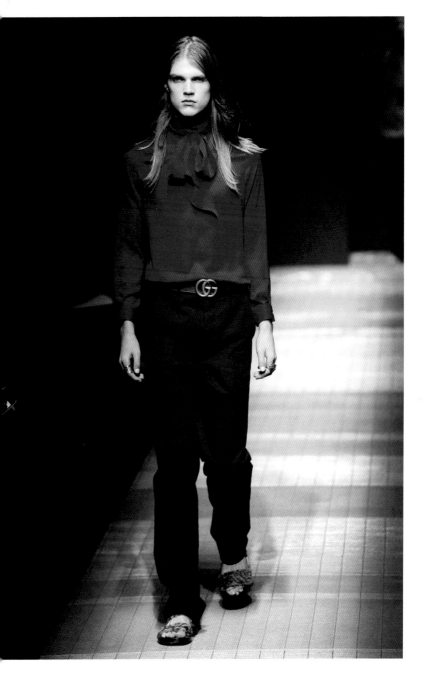

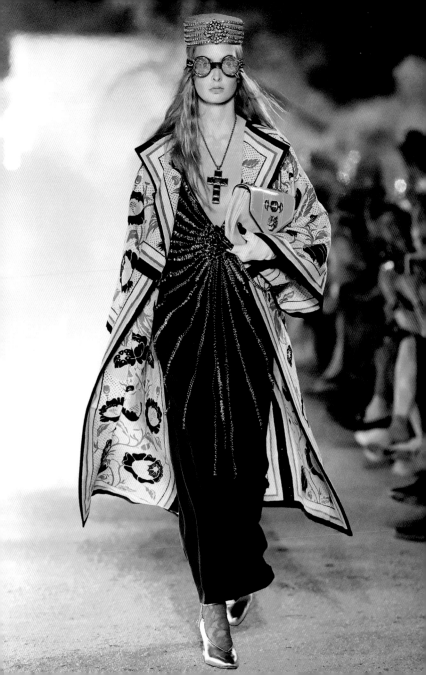

Michele is a striking-looking man, with Messiah-like, long, flowing black hair and matching beard, and his love of heels and eccentric dress sense give him an impressive presence. His flair for theatrical design and the cinematic quality of his catwalk shows come as no surprise when you learn that the designer, who was born in Rome in 1972, studied costume design at Rome's Academy of Costume and Fashion. He also credits his mother, who worked as an assistant to a Rome film executive and "was really obsessed with American movies and cinema. For her it was like a religion." His hippy, nature-loving father, on the other hand, was "a bit of a shaman, with long hair and a beard". Many of the totemic motifs that have come to adorn Michele's designs can be attributed to his father's influence.

Despite his talent for theatre and costume design, Michele decided that fashion would be a more appealing career choice, and he worked first for Fendi (as did Giannini). There he was taken under the wing of Karl Lagerfeld, until Michele joined Gucci's design studio in London in 2002 at the invitation of Ford. He went on to work in a number of design roles at Gucci, rising through the ranks to head up accessories and become one of Giannini's closest design assistants.

OPPOSITE While some of Michele's eclectic creations might be seen as brilliant but hard to wear off the catwalk, others are simply elegant and beautifully designed such as this long dress with its colourful starburst and floral-patterned coat with kimono sleeves.

Michele had already given the fashion world a taste of what he was capable of when he stepped in to salvage the Autumn/Winter 2015 menswear show in just five days, following the abrupt departure of Giannini. Just days later his appointment as designer-in-chief was announced. A month after that he presented his debut womenswear show, which was an immediate hit. As American *Vogue*'s Hamish Bowles put it, "In that single collection he reset the dial at the house, introducing a quirky runway cast wearing gender-neutral clothes that drew on his passion for eclectic vintage references and antique accoutrements."

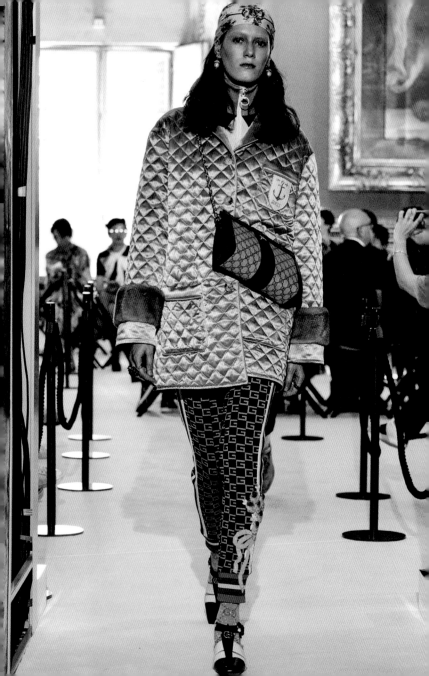

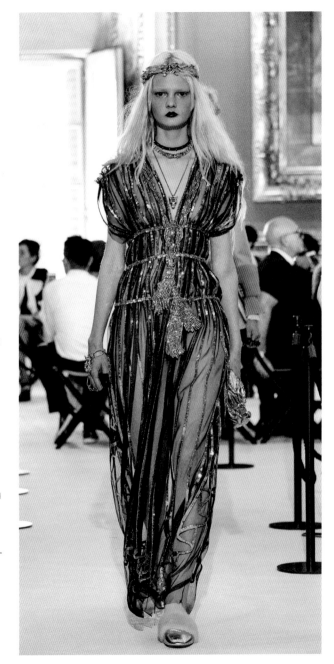

LEFT Model Lea Issarni in a Resort 2018 look as inspired by streetwear as by the Renaissance.

RIGHT Model Unia Pakhomova wears a semi-transparent Grecian-style dress with gold stripes and heavily sequinned silver detail complemented by a headdress modelled on a gold laurel wreath in Michele's historically-inspired 2018 Resort collection shown at Florence's Pitti Palace.

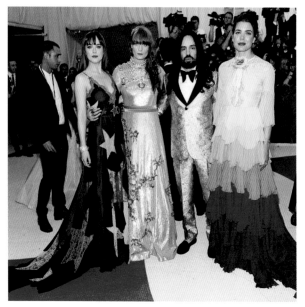

LEFT At the 2016 Met Gala, Gucci dressed Dakota Johnson, Florence Welch and Charlotte Casiraghi. Michele attended in a silver brocade suit.

The show immediately established Michele as a very different designer to either Giannini or Ford. A true modern romantic, his sensuality is infused with emotion rather than the cold, hard sex appeal of Ford's 1990s designs. Likewise, Giannini's poised formality, evoking the image of the haughty lifestyle of the social elite, could not be further from Michele's effusive eccentricity. A self-confessed magpie of all things old and interesting, Michele admitted shortly after his appointment that he is obsessed with antiques and the past. "I'm not interested in the future – it doesn't exist yet – but I'm really interested in the past and the contemporary. My apartment is full of antique pieces, but I put everything together like a modern installation."

Likewise, with his first show, the feel was vintage boho, full of plenty of frills, flounces and florals. Models, both male and female, paraded down the catwalk in pussy-bow blouses, librarian glasses,

OPPOSITE Actor and singer/songwriter Jared Leto, who is often said to look uncannily like the Italian designer, is a good friend and muse to Michele and almost exclusively wears Gucci, often one-off creations made especially for him.

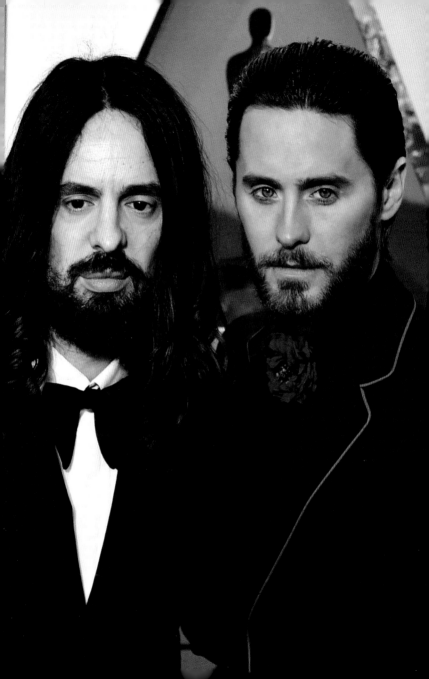

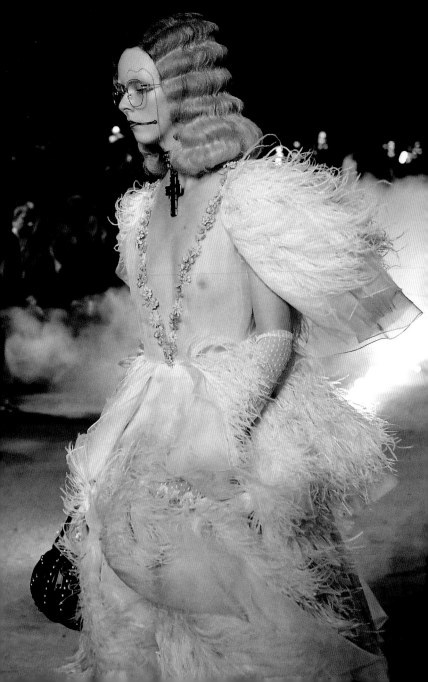

OPPOSITE A dramatic look from the Resort 2019 collection. Constructed from chiffon and marabou feathers, the ethereal gown contrasts with black studded leather accessories.

RIGHT For his 2017 Resort collection, fittingly shown in Westminster Abbey, Michele paid homage to British designers such as Vivienne Westwood with a Union Jack sweater, Queen-like headscarf and handbag and even an appliquéd corgi dog, albeit adorned with a crown of flames.

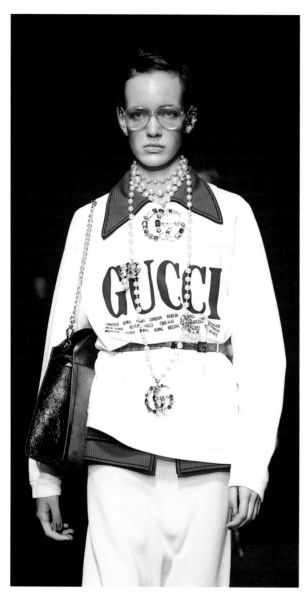

LEFT Part of Michele's success has been in taking the millennial backlash against ostentatious label flaunting that saw Gucci's profits suffer and giving it an ironic twist. Sweatshirts with "Gucci" emblazoned across the chest are so in-your-face that they are cool again.

OPPOSITE This iconic Gucci black patent Horsebit loafer is given a Michele twist with the addition of a Donald Duck embellishment for Spring/Summer 2017.

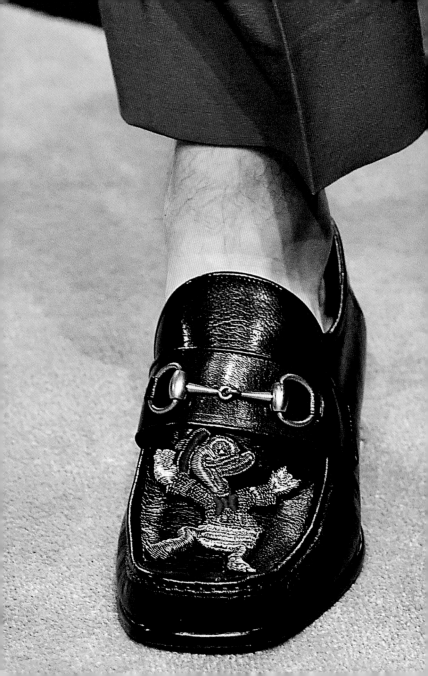

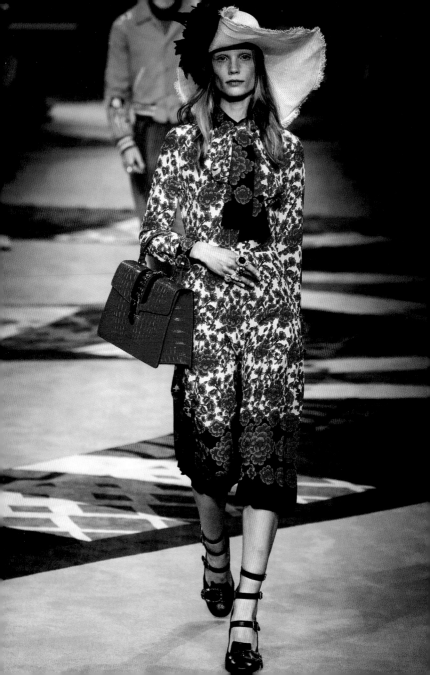

floral suits, and sweaters with elaborate bird and flower motifs, and, like the designer himself, they wore numerous vintage rings, but the overall effect is somehow refreshingly contemporary.

Another noticeable departure from his predecessors was the way in which Michele played with proportions: dresses were shapeless and jackets were exaggeratedly oversized, with fur cuffs that ended only just below the elbow. Nothing could be further from the traditional Gucci look, where a body-skimming silhouette was paramount. And while the iconic Gucci elements were still there, it wasn't in quite the sophisticated way that we had come to associate with the brand. For example, a double-G belt sat atop a flared peasant skirt and the sleek Horsebit loafers came backless and lined with kangaroo fur. The overall effect was not as polished as some might have expected from a brand like Gucci, but it expressed a young, playful mood that would come to redefine the house.

Six months later, at the presentation of Michele's Spring/Summer 2016 collection, the fashion world was raving about the newcomer at Gucci. Called on more than one occasion a "fashion Jesus" (appropriately given his long, Messiah-like locks), he really does seem to see visions others don't.

As Sarah Mower put it in British *Vogue*'s critique of his show, "Alessandro Michele is in the spotlight as the Pied Piper of change – a risk-taker and revolutionary who has not so much wiped the slate clean at Gucci as doodled all over it, coloured it in, stuck sequins on it, and tied it up with a grosgrain bow."

His staging, too, had been transformed for his second show. Rather than use the same dark and smoky nightclub setting that so suited Gucci's previous 1970s disco vibe, Michele instead presented models against the backdrop of a disused train depot, the catwalk itself covered in a printed carpet. Models displayed an orgy of colour, print and texture. Fabrics

OPPOSITE Fluidity is key to the Gucci aesthetic under Michele. A model in the Spring/Summer 2017 menswear show wears a floral printed day dress with patent crocodile boxy bag.

OVERLEAF Kaleidoscopic colour and texture in the Spring/Summer 2017 show. Inspired by 1970s nightclubs and Renaissance Venice, the collection was by turns opulent and mournful.

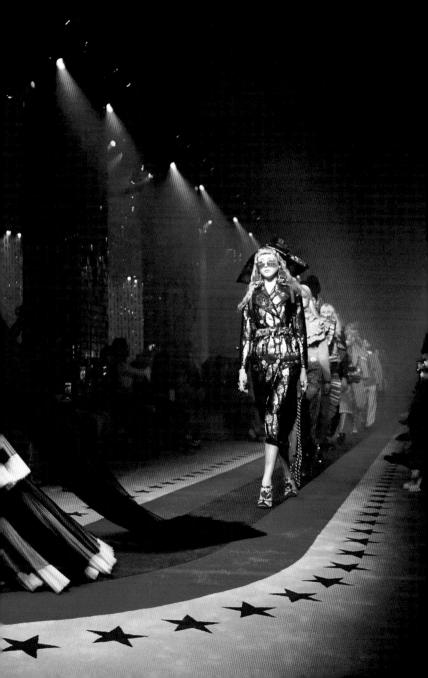

ranged from knitted Missoni-style lurex to floral chiffon and lace, with many wildly varied printed designs. The 1970s references were there, but, speaking backstage, Michele said he had been more influenced by the Renaissance. Most impressive of all was the design team's attention to detail, offering a range of embellishments that left fashion commentators buzzing with excitement. As the designer himself admitted, "It's a big trip!"

Again, not forgetting this was a Gucci show requiring the inclusion of the label's traditional status symbols, Michele showed his knack for the unexpected, including them as a complement to more eclectic garments. For example, a model in a grass-green, semi-transparent, floral lace dress wore a red–green web stripe belt and interlocking-G loafers, and carried a traditional Gucci structured handbag. These bags, in the stiff-framed style favoured by Queen Elizabeth II (or for an apt 1980s reference, Margaret Thatcher), have been one of Michele's great success stories for Gucci. Redesigned in bright colours, embossed with embroidered floral motifs and sequins, or given a street-art touch, he has managed to make them desirable to a whole new generation of Gucci fans.

The year 2015 was a significant one for both Gucci, back on the map thanks to its new designer-in-chief, and for Michele himself, who was named as the recipient of the 2015 International Designer Award, in recognition of his remarkable achievements. Since then the designer has gone from strength to strength, with *Vogue* calling him "the most-copied fashion-diviner on Earth".

In 2016 retro influences abounded, from the sixteenth century right through to the 1980s, with medieval cherubs finding their way onto a striking, printed red silk and Medici-style pearl-trimmed bodices juxtaposed with urban accessories or puffy 1980s sleeves. Always the geek-chic oversized or coloured glasses

OPPOSITE Michele's catwalk creations are incredibly intricate with multiple influences in one. For Spring/Summer 2018 model Nicole Atieno wears an 80s exaggerated-shouldered, bright blue velvet, rose-embossed jacket over a 70s-style blouse with a quilted floral print skirt. Multiple beaded necklaces offset two classic Gucci bags, coloured paste brooch, statement drop earrings and oversized librarian glasses.

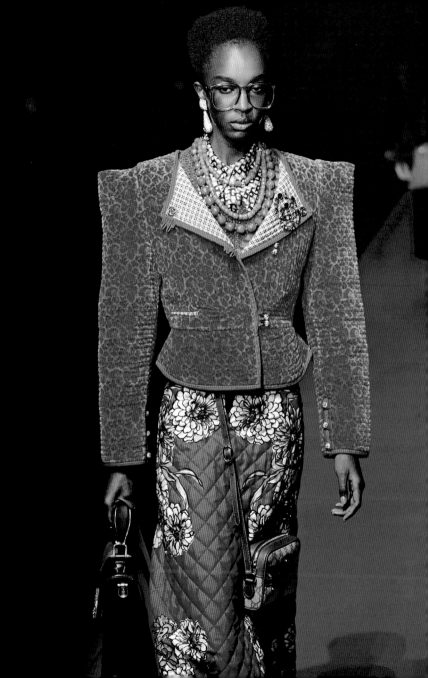

were a common accessory, but there was plenty of street style, too, with urban motifs including a Gucci G spray-painted onto biker jackets by New York street artist and musician Trouble Andrew. And in case you were bored, a model then appeared completely colour-blocked in head-to-toe saccharine hues including candy-floss pink, turquoise and canary yellow (actually resembling a giant bird, as the mainstay of the outfit was a feather-like fur coat), but it all worked in the continuity of Michele's strange brilliance.

The Spring/Summer 2017 collection was glitzier, with a more clubby feel, yet continued the 1970s–Renaissance theme and even included a five-inch wedge version of the Venetian "chopine" – a platform shoe worn by fifteenth century ladies, who needed to be elevated well above street level to avoid lakes of sewage and other filth – along with 1970s tweeds and 1980s frothy, ruched cocktail dresses. Michele's attention to detail, and acknowledgment that even his craziest catwalk creations ultimately needed to be wearable, had him include in his platforms a removable flat slipper with a delicate rose-bud printed insole.

Ever evolving, Michele is clearly influenced by many different cultural phenomena: street style, digital media and pop music, to name but a few. His meeting with Elton John, who he now counts as a friend, at the *GQ* Man of the Year Awards, and John's admission that he is a fan of Michele, led to an homage to the legendary musician in the form of a flared, tweed suit accessories with oversized, glittery 1970s glasses. Florence Welch, introduced to Gucci in Giannini's time, was another inspiration, and the singer became an ambassador for the brand in 2016. And, of course, there's Michele's doppelgänger, Jared Leto, who is such a good friend and muse of the designer that he almost exclusively wears Gucci outfits, many of which are one-off creations.

One of the boldest decisions that Michele made, right from

RIGHT After meeting at the *GQ* Man of the Year Awards in London in 2016, Michele struck up a close friendship with Elton John. He designs exclusive outfits for the singer and finds frequent inspiration for his collections in the star's trademark style, including seventies disco-wear and oversized glitzy glasses.

the beginning of his tenure at Gucci, was to cast both male and female models to appear in all his runway shows and not differentiate between male and female clothes. In fact, his debut show opened with long-haired model Hugo Goldhoorn in a red silk pussy-bow blouse, a brave move from an unknown designer taking over at an historic, global fashion house. And in February 2017 he presented his first combined mens-and-womenswear show to reveal his Autumn/Winter collections.

Of course Gucci is no stranger to androgyny, with Ford embracing slit-to-the-waist satin shirts and the infamous Gucci G-string for both men and women, while Giannini was inspired by the gender-blurring style of Bowie. Michele, however, appropriately in these days of gender fluidity, doesn't see

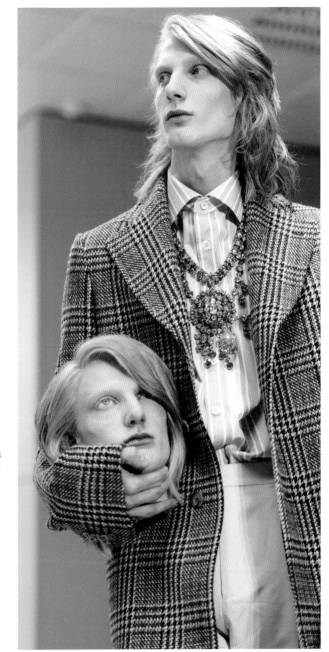

RIGHT For Gucci's Autumn/Winter 2018 show Michele pushed his designs well out of most people's comfort zone. Staged in a series of operating theatres, the show featured several models who carried versions of their own heads.

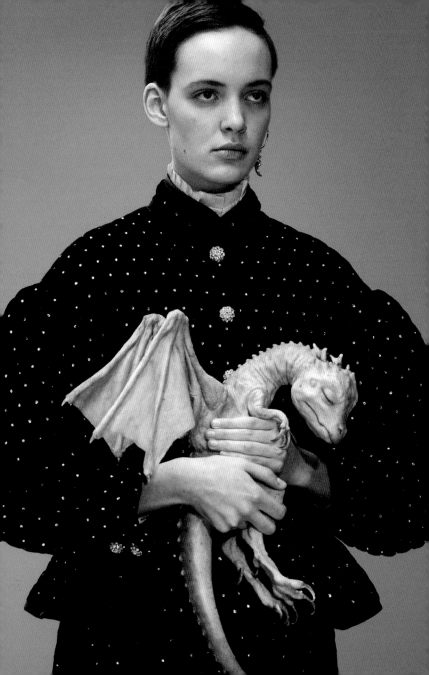

why any clothes should be assigned to one particular gender. For consumers, floral suits might not be such a stretch, but silk babushka scarves and even full-on evening gowns are fair game as men's clothes for the designer. And, as always, Michele has proved prescient, with male celebrities embracing his outfits. Jared Leto memorably turned up to the 2019 Metropolitan Museum of Art's Costume Institute Gala wearing a Renaissance-style red evening gown and carrying a model of his own head as an accessory, an outfit that Michele had designed for him, saying it would make him look like a character from Shakespeare.

But it is not necessary to go to such extremes to recognize how Michele has reshaped men's fashion. Simply allowing men to step away from the safety of traditionally masculine fabrics and colours, instead embracing glamorous textures and vibrant hues including velvets and silks rich with embroidery and embellishment, has redefined what is to be a millennial man. Michele's fans are as widely varied as Roger Federer, Dapper Dan, Sir Elton John and Snoop Dogg. Along with Leto, his most recent fan and muse is British pop star Harry Styles, with whom he has collaborated on designs and in advertising campaigns. As Michele summed it up in an interview with *GQ* magazine, "I think Harry is the perfect expression of masculinity. He is so relaxed in his body, and completely open to listen to himself. He likes to play with dress, with hair … [and] is really in contact with his feminine part. He's sexy and he's handsome."

Even with his clear acceptance of the wide variety of human expression, Michele has not been immune to causing offence. For example, the inclusion of a black balaclava-style jumper in his new collection in 2019 led to accusations of racism. The garment was likened to the once-common practice of blackface

OVERLEAF The full kaleidoscopic brilliance of Michele's design genius can be seen here as the models pose at the end of his Spring/ Summer 2019 show.

OPPOSITE The Autumn/Winter 2018 show also included a model carrying a macabre baby dragon and wearing a long black robe, reminiscent of medieval priests though dotted with crystals.

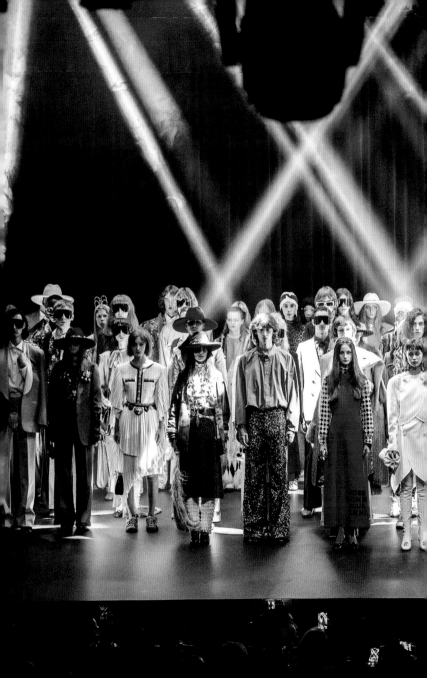

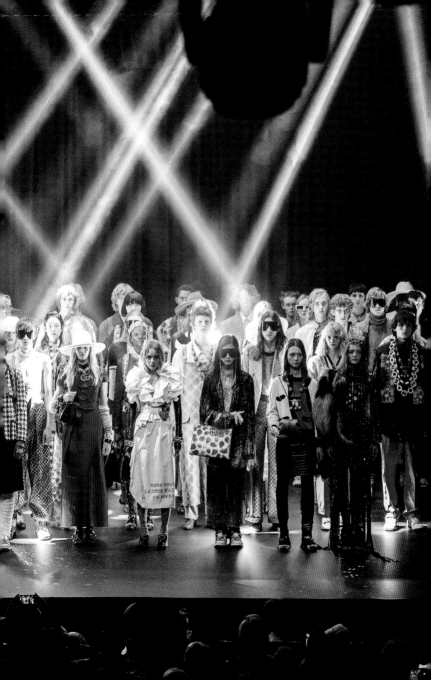

make-up, which is now rightly seen as racially offensive. The designer immediately issued a heartfelt apology, explaining that the intention was to reference the performance artist and fashion designer Leigh Bowery, who used flamboyant make-up, and that he had not appreciated the racial connotation. The item was removed from sale and subsequently Gucci announced a programme of diversity awareness, with Michele stating, "I hope I can rely on the understanding of those who know me and can acknowledge the constant tension towards the celebration of diversity that has always shaped my work."

Gucci's sales figures confirm that Michele is not just beloved of the fashion crowd, although deservedly he is revered as one of the most creatively remarkable designers for a long time. His ability to poke fun at the grabby status symbol of the 1980s and 1990s has sparked some truly memorable creations, including the ironic "Guccy" logo, printed on sweatshirts atop a sequinned tiger's head and emblazoned on bags, which was an instant hit with the Instagram generation. Michele's collaborations for Gucci, including with the New York Yankees, have helped redefine the brand for a new generation, and Michele's animal motifs – lions, wolves, tigers and serpents – have become as iconic as the red–green–red stripe and double-G logo, both on products and in advertising campaigns. Named brand of the year in 2017 by *The Business of Fashion*, Gucci has outstripped its competitors under a designer-in-chief who doesn't so much push boundaries as refuse to acknowledge they are there. From ignoring gender stereotypes to learning from criticisms on diversity, Michele is more than just a designer, and his fashion is more than just the clothes on the models. As he himself explained, "Sometimes people think that fashion is just a good dress, but it's not. It's a bigger reflection of history and social change and very powerful things."

OPPOSITE Fetish masks with two-inch spikes might seem to be included for shock value only but Michele is fascinated with how we choose clothes to express or disguise parts of ourselves. "A mask is hollow but also full," he said at the press conference after the show for Autumn/Winter 2019.

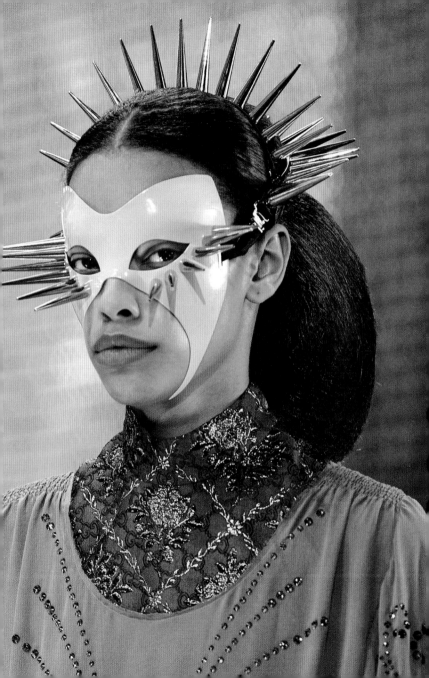

A Cult Icon

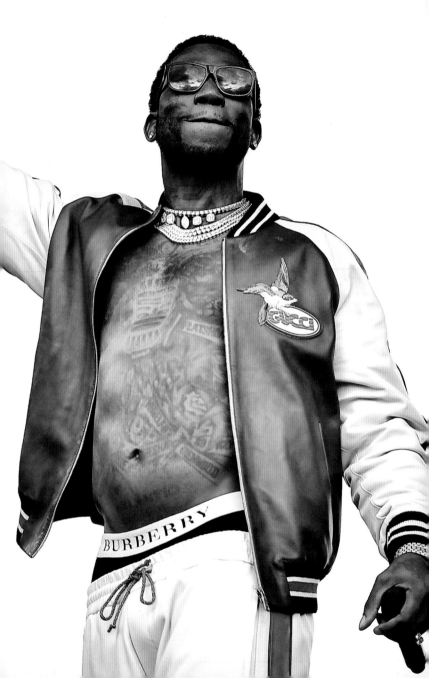

HIGH FASHION
MEETS
STREETWEAR

A huge part of Gucci's success has been the creation of instantly recognizable iconic items that infuse the wearer with the brand's identity.

From the patenting of the interlocking double-G logo in the 1930s, through the Horsebit loafers, Jackie O bag and Flora print of the 1950s and 1960s, to Tom Ford's skinny double-G belt snaking around hipster trousers, Gucci's products proudly proclaim who they are. Guccio Gucci's vision for his brand was of an aspirational luxury goods label that catered to an elite of aristocrats and film stars, and for the display of a Gucci status symbol to communicate the wearer's impeccable taste, style, and above all their wealth. As Frida Giannini found out to her cost, the smart designer today needs to gear their offering towards millennials, celebrities and street-style icons in order to achieve cultural relevance and financial success.

Fortunately for Gucci, with the arrival of designer Alessandro Michele, the brand's image has morphed once again to become synonymous with not just wealth but cutting edge cool, too.

OPPOSITE Rapper Gucci Mane took his name from his own love of the brand and its connotations. He is the face of the Resort 2020 collection.

Michele's design genius, blending his natural leanings towards vintage eclectic with his love of contemporary culture and street style, led immediately to the redesign of signature pieces. For example, his first show revealed a twist on the Horsebit loafer, shorn of its back and lined with kangaroo fur, and his tongue-in-cheek versions of classic bags with liberal sprinklings of sequins and kitsch animal motifs have become instant bestsellers.

Michele had an immediate effect on the desirability of the label, so much so that, as Robin Givhan, fashion critic at the *Washington Post,* explained shortly after the designer's appointment in 2015, old-school Gucci accessories were once again cool. "That's what's been so interesting about what's happening at Gucci," Givhan said. "Alessandro has been able to help revive the whole idea of Gucci, and not just Gucci Spring/Summer '16."

These redesigned accessories have become Gucci's new cult icons and in turn helped boost the company's profits. (With a 2020 revenue target of 10 billion euros within reach, Gucci is close to overtaking Louis Vuitton, currently the world's largest luxury brand.) In particular, Michele has introduced a series of standout bags including the Soho Disco – a relatively minimalist style made from textured leather with an embossed Gucci double-G logo, cross-body strap and oversized tassel detail – and the Dionysus – a larger, structured bag identifiable by its metal clasp featuring two tiger heads. Michele also successfully relaunched the classic Sylvie bag, with its distinctive gold-toned chain and buckle closure, tracing its heritage back to 1969 and the Moon landing. Belts, too, are one of the more coveted of Gucci's accessories, not beyond the dreams of a twenty-something, cost-wise, and in 2019 shopping site Lyst saw 110,000 global online searches a month for the double-G belt in menswear alone.

But it is some of the more outlandish creations of Michele that have really spoken to the young generation, including

OPPOSITE Alexa Chung at the Gucci timepieces and jewellery presentation, 2016, wearing the iconic double-G belt.

RIGHT Gucci has become so popular among the fashion crowd that the logo is often spotted in fashion week street style editorials such as this picture from Milan in 2017.

OPPOSITE The Gucci Soho bag, with its embossed logo on soft leather and trademark tassel, was launched in 2014 and has become one of Gucci's most successful modern icons. It is worn here by actress Emma Roberts.

streetwear emblazoned with cartoons of his pet dogs or with the ironic "Guccy", and bum bags (or fanny packs as they are known in the US) in Gucci's signature print. His eclectic mix of motifs including the double-G turned into a red apple or sequinned flower, embroidered lions and other animals, and lightning bolts, have updated Gucci's traditional accessories into something far more current.

Gucci deserves credit, too, for its social media savvy, including the brand trending on Instagram with a meme created for the launch of a new timepiece campaign and accompanied by the hashtag #TFWGucci (that feel when). Among the humorous images was one of a swimmer wearing a watch, captioned, "When you have Aquagym at 3pm but you need to accessorize your existential angst eternally."

There are other ways, too, in which Gucci maintains its status as the most sought-after luxury brand, in music, for example, especially rap – a 2015 survey for Macy's saw Gucci topping the chart as the most name-dropped brand in hip-hop of the previous 20 years. The brand's name itself has entered the lexicon, becoming a popular slang adjective meaning "cool"

OPPOSITE The limited run of around 600 Gucci Loves New York bags, designed in 2008 as part of a promotion for the opening of the brand's 460,000-square-foot flagship store with all proceeds going to charity, has become a modern cult classic.

RIGHT Shown here in purple quilted velvet the Gucci Marmont Matelasse bag is another modern icon.

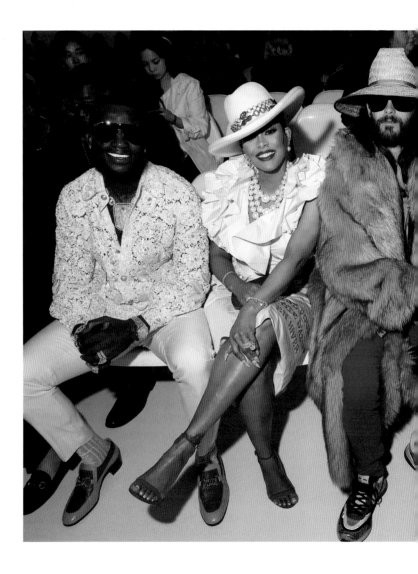

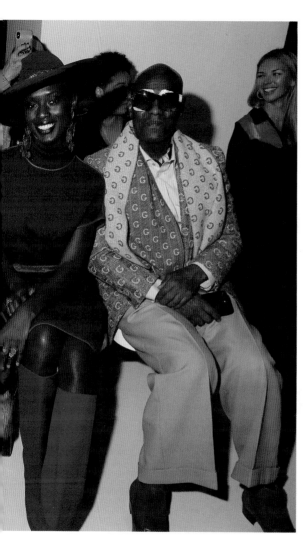

LEFT Celebrity fans turn out in their finery on the front row for the Spring/Summer 2020 presentation in Milan. From left: rapper Gucci Mane, actor Keyshia Ka'oir, actor and singer/songwriter Jared Leto, actor Jodie Turner-Smith and iconic tailor Dapper Dan.

or "good", as in "it's all Gucci". And *Urban Dictionary* defines "Guccify" as "to bling out; to add high-end qualities to a product or service (or outfit); to make something overly impressive, expensive, or elaborate."

Michele (who was himself immortalized in rapper Jermaine Dupri's song 'Alessandro Michele') has embraced Gucci's popularity with hip-hop artists and fans, casting Gucci Mane for the 2020 Resort campaign and joining forces in 2017 with Harlem tailor Dapper Dan, who was once sued by Gucci (and other luxury brands) for ripping off their logo in his own unique take on street style, or as he calls it "high-end, ghetto-fabulous clothing". Marco Bizzarri, Gucci's CEO and the man responsible for promoting Michele to designer-in-chief, is determined to maintain the brand's "post-ironic" status and relevance to millennials, something he is already achieving. More than half of Gucci's newly doubled sales in 2018 came from buyers under 35, according to *Business Insider*. And with Michele's never-ending imagination when it comes to innovative, fresh, new fashion, Gucci's ascent seems unstoppable. In an interview with *Fast Company* magazine, Bizzarri again stressed the importance of doing something unique and authentic:

"The point is that if you are able to spontaneously and genuinely talk to millennials in a way that they can see really comes from the heart, you are talking their language … This genuine passion is something that can keep us ahead of the competition. I've read many things about millennials these days saying they are not loyal and switch from one brand to the next. This may be true, but it doesn't apply to us."

OPPOSITE Rapper 2 Chainz wears a Gucci signature Diamante print jacket to the BET Awards in 2018.

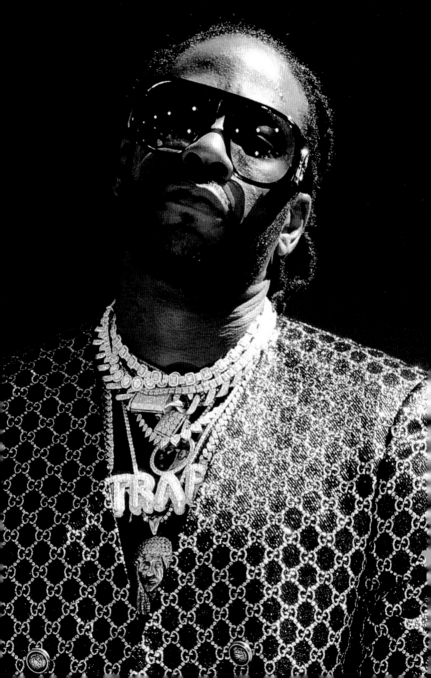

INDEX

CREDITS

The publishers would like to thank the following sources for their kind permission to reproduce the pictures in this book.

Alamy: Grzegorz Czapski: 29; /WinkinPink Picture Library 71

Bridgeman Images: 26; /The Advertising Archives 40; /Reporters Associati & Archivi/ Mondadori Portfolio 34t; /Roberto Carnevali/ Reporters Associati & Archivi/Mondadori Portfolio 37

Getty Images: Bettmann 24; /Victor Boyko 152-153; /Vittorio Zunino Celotto 6, 11, 100, 112, 115; /Paolo Cocco/AFP 72; /Erin Combs/Toronto Star 20; /Denver Post 8; / Pietro D'Aprano 118, 119 /Todd Duncan/ Newsday 44; /Estrop/WireImage 126; / Farabola 43; /Terry Fincher 45; /Charley Gallay/Getty Images 146; /Paras Griffin/ WireImage 144; /Horst P. Horst/Conde Nast 36; /Hulton-Deutsch Collection/Corbis 42; / Gerard Julien/AFP 64; /Mansell/The LIFE Picture Collection: 16; /Guy Marineau/Conde Nast 52, 53, 54; /David McGough/The LIFE Picture Collection 33; /Miguel Medina/AFP 131; /Filippo Monteforte/AFP 135, 136; / Antonio de Moraes Barros Filho/WireImage 98-99; /Han Myung-Gu/WireImage 108; / Cornel Cristian Petrus 149; /Jacopo Raule 122; /Bob Thomas/Popperfoto 49; /Venturelli/

WireImage 86, 90, 93, 116, 123, 124, 128-129, 138-139, 141; /Victor Virgile/Gamma-Rapho 104, 106, 109, 125; /Theo Wargo/WireImage 101; /Edward Wong/South China Morning Post 75, 91

Heritage Auctions, HA.com: 9, 19, 26b, 31t, 31b, 74t, 74b, 84t, 84b, 96, 150, 151

Courtesy of Kerry Taylor Auctions: 30, 35

Private Collection: 26t

Shutterstock: 18; /Matt Baron 132; /Michael Buckner/WWD 120; /Domenico Esposito 34b; /Fairchild Archive/Penske Media 59, 66, 77, 82, 86, 89, 94; /Granger 17; /Paul Hurschmann/AP 57; /IPA 46; /Mark Large/ Daily Mail 60, 63; /Cavan Pawson/Evening Standard 67, 68, 78-79; /Reset 70; /Startracks 10, 148, 155; /Ken Towner/Evening Standard 65; /Andrew H Walker/WWD 121; /Wood 69; / Richard Young 134

Topfoto: 14

Every effort has been made to acknowledge correctly and contact the source and/or copyright holder of each picture and Welbeck Publishing apologizes for any unintentional errors or omissions, which will be corrected in future editions of this book.